THIS HIRAMEKI BOOK DONE BY:

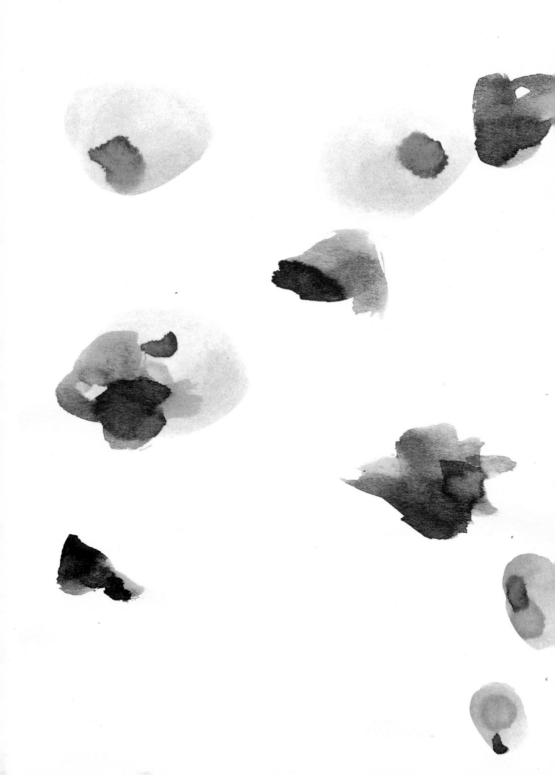

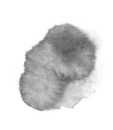

Peng + Hu

HIRAMEKI®

DRAW WHAT YOU SEE

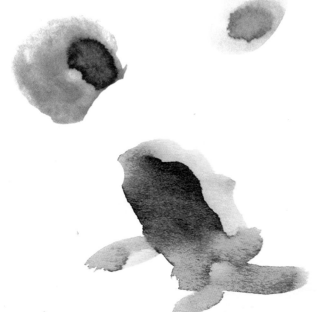

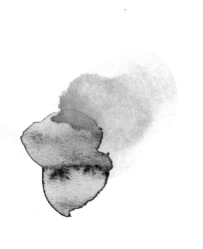

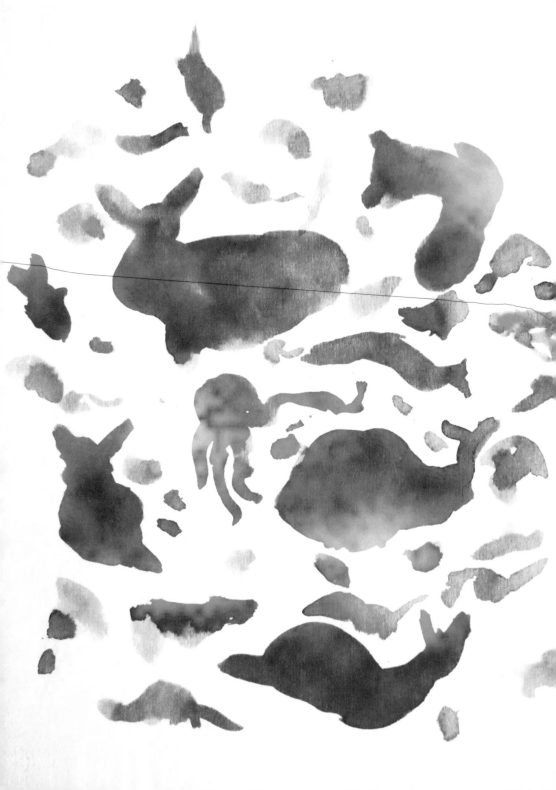

IN THE BEGINNING WAS THE BLOT.

A FLASH OF INSPIRATION, A LIGHTBULB MOMENT, A STROKE
OF GENIUS...

WITH JUST A FEW STROKES OF THE PEN AND A DASH OF YOUR
IMAGINATION HIRAMEKI GIVES A SUBLIME AND UNEXPECTED SENSE
OF SATISFACTION AND DELIGHTS THE HAND, EYE AND MIND.
THE LITTLE BLOT WILL REVEAL ITS TRUE SELF.

HIRAMEKI: PLEASURE FROM THE SMALLEST THINGS.

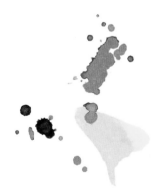

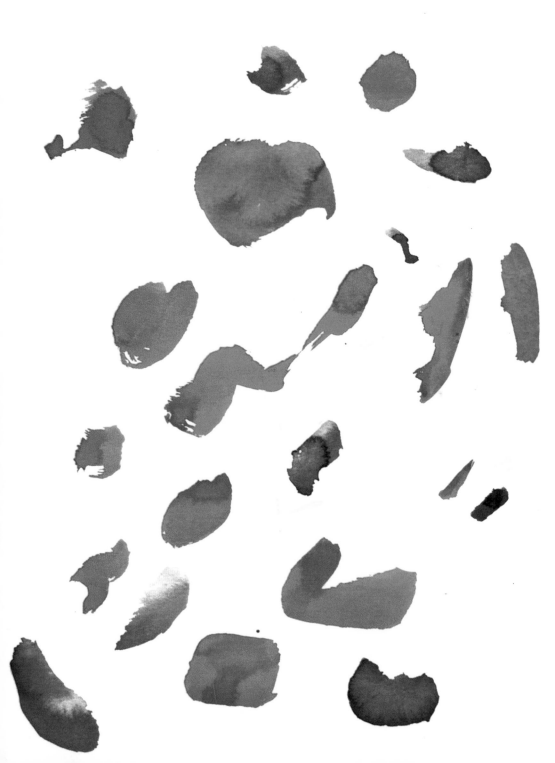

THE SEVEN STEPS OF HIRAMEKI

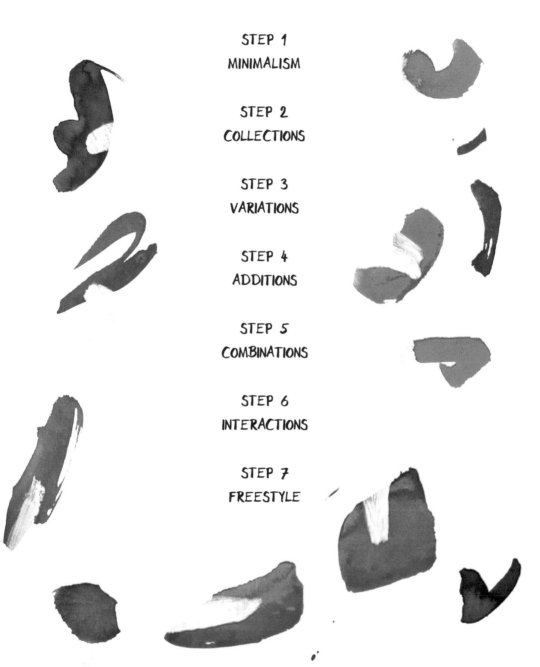

STEP 1
MINIMALISM

STEP 2
COLLECTIONS

STEP 3
VARIATIONS

STEP 4
ADDITIONS

STEP 5
COMBINATIONS

STEP 6
INTERACTIONS

STEP 7
FREESTYLE

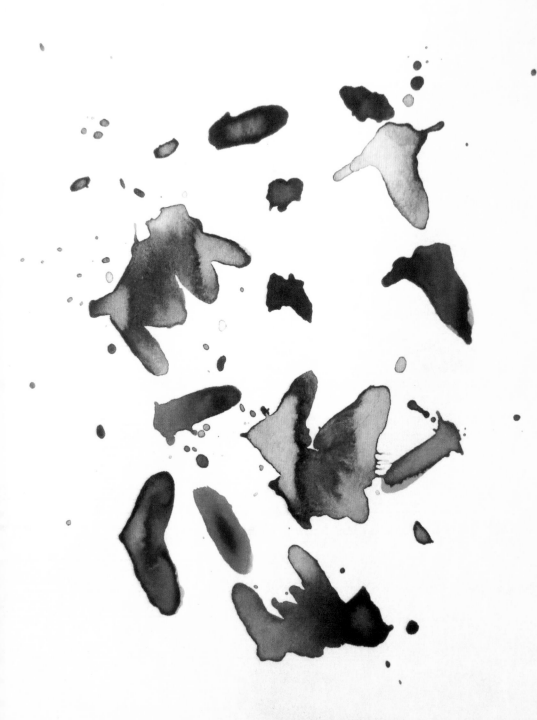

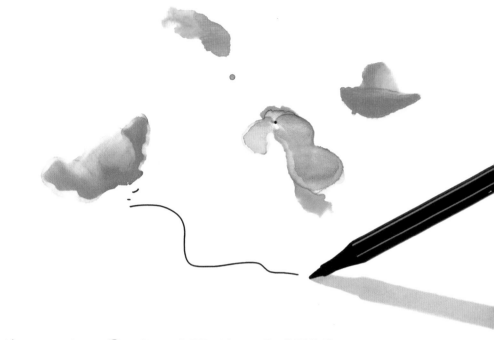

HAPPINESS = BLOT + STROKE OF GENIUS

THE PERFECT HIRAMEKI PEN SHOULD BE NO LONGER THAN
YOUR ARM, AND NO SHORTER THAN YOUR LITTLE FINGER.
THE INK SHOULD BE COALBLACK OR MIDNIGHT BLUE,
BUT NEVER SHRIEKY YELLOW OR SHRINKING VIOLET.

JAPANESE CALLIGRAPHY BRUSHES ARE ACCEPTABLE,
AS ARE POLISH GOOSEFEATHER QUILLS OR BELGIAN CHARCOAL.

BEST OF ALL, THOUGH, IS A FINE-TIPPED FELT PEN.
USE LIPSTICK AND SPRAY CANS ONLY IF DESPERATE.

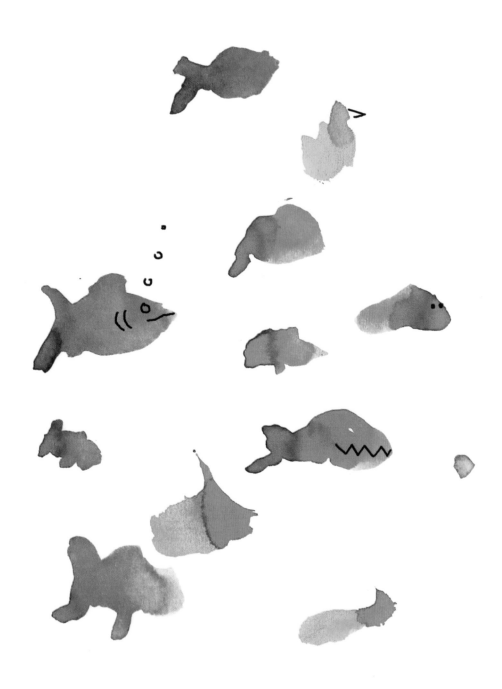

HIRAMEKI

STEP 1

MINIMALISM

LITTLE LINES, BIG RESULT

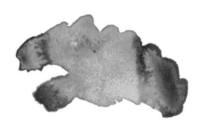

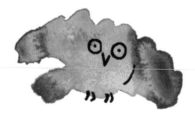

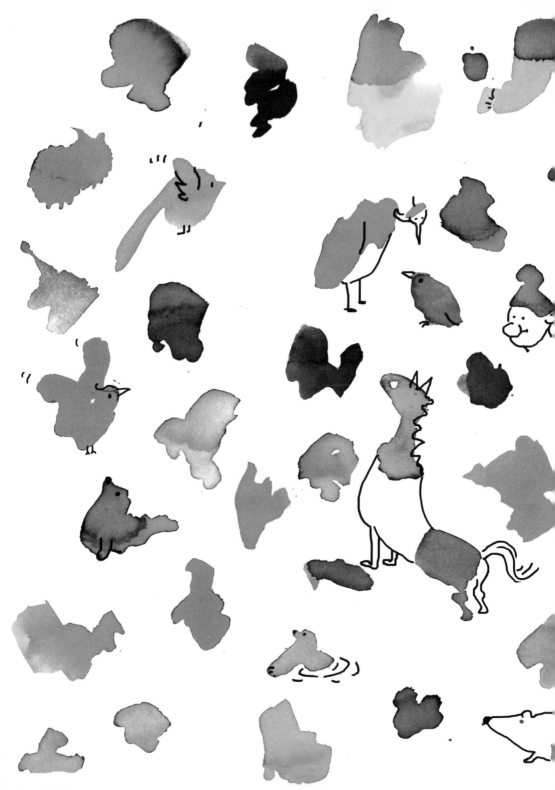

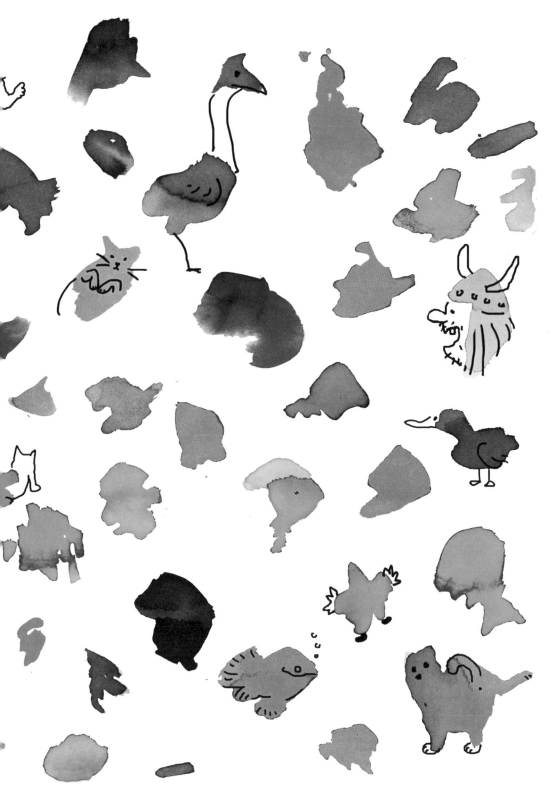

BUGS FLY AND BEETLES CRAWL...

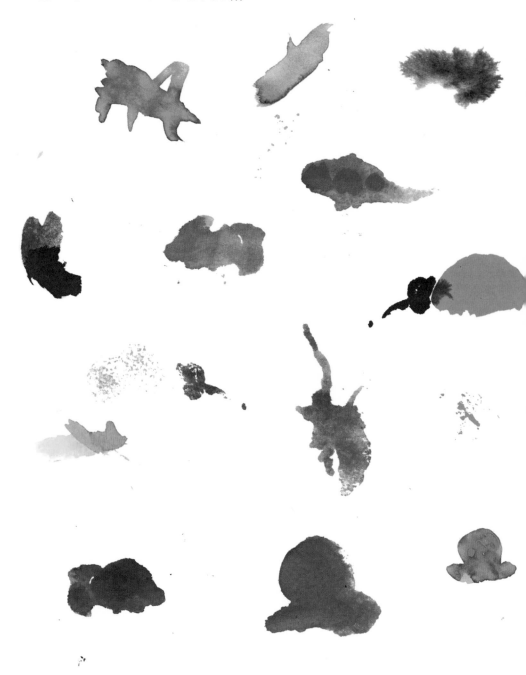

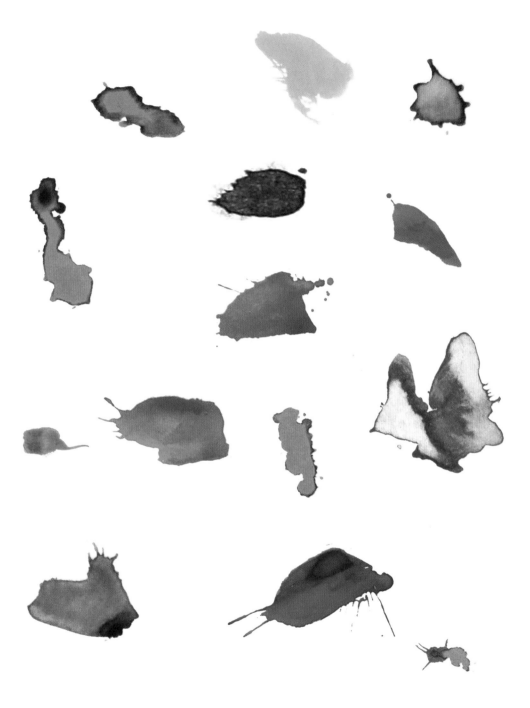

...IN THESE BLOTS YOU SEE THEM ALL.

FUZZY HEAD OR FACIAL HAIR...

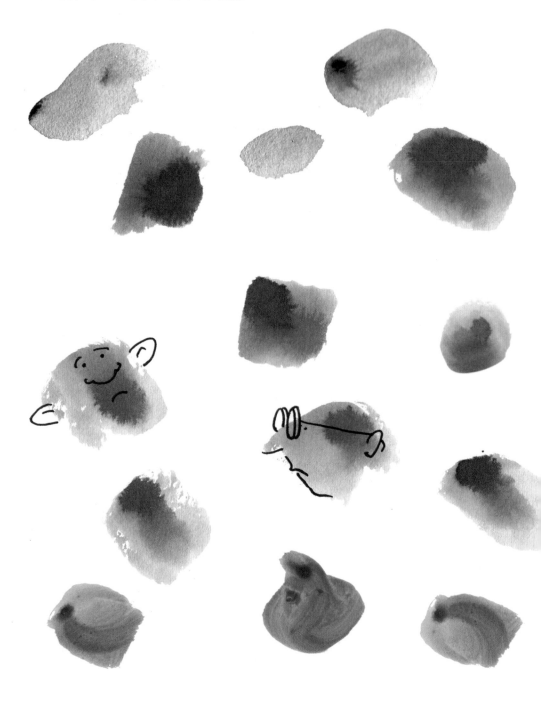

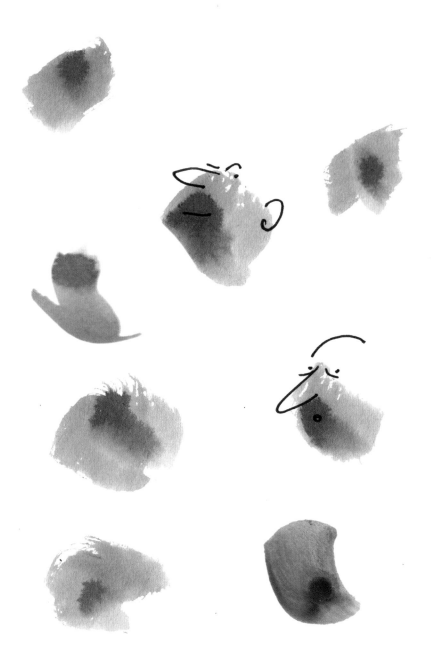

FACES IN A CROWDED ROOM.
ISN'T THAT YOU KNOW WHOM?

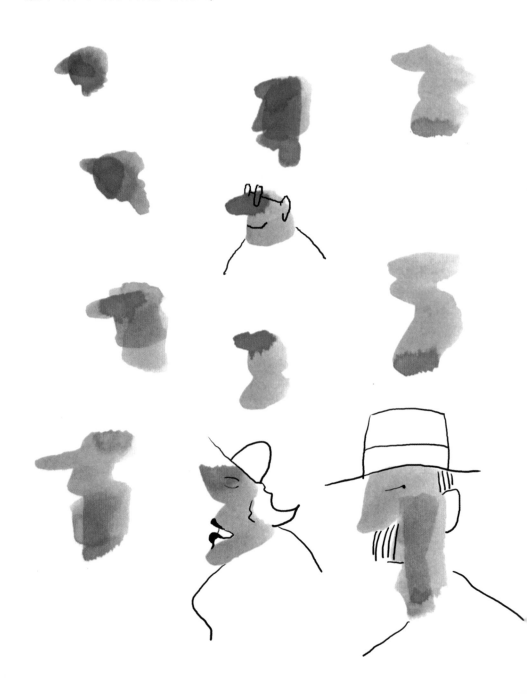

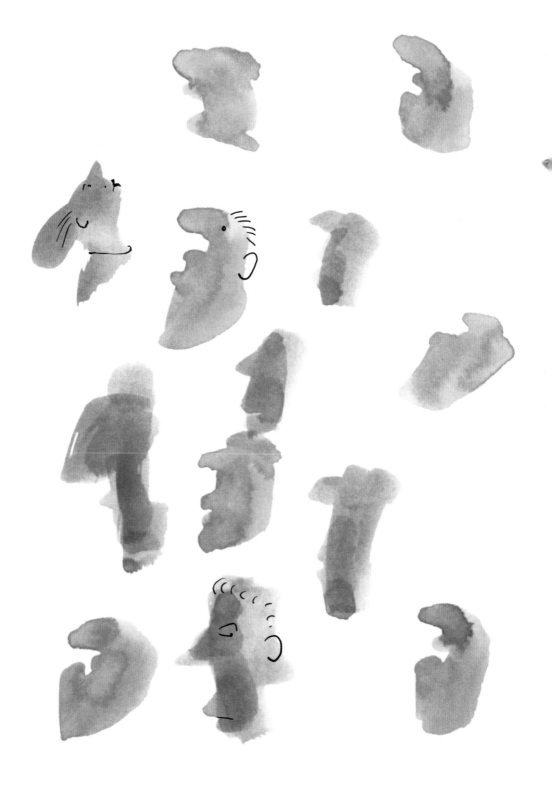

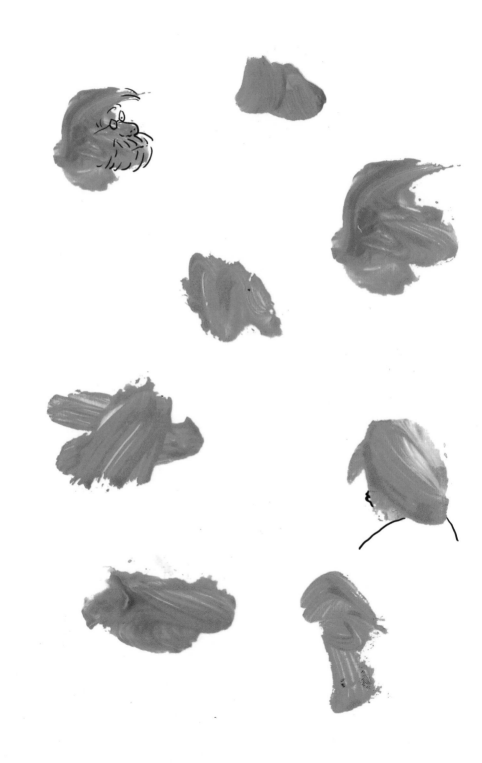

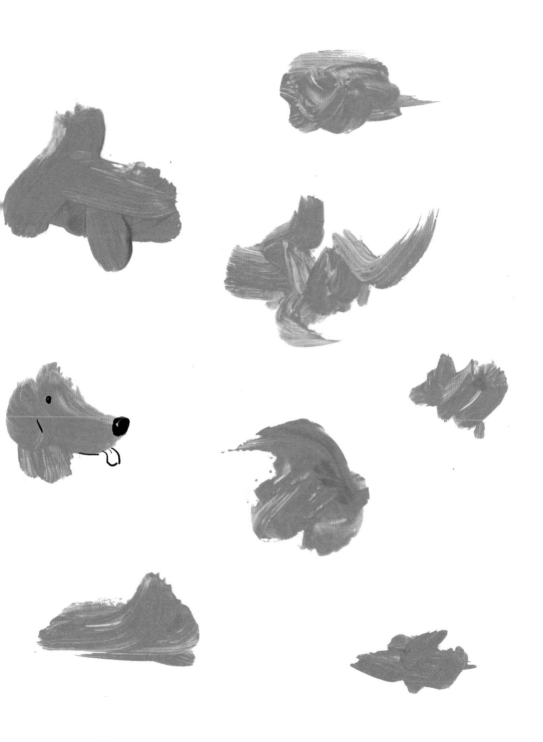

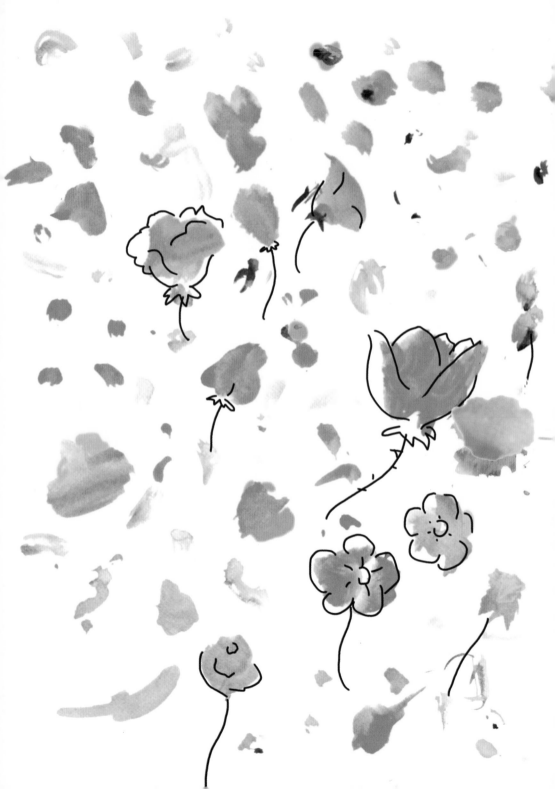

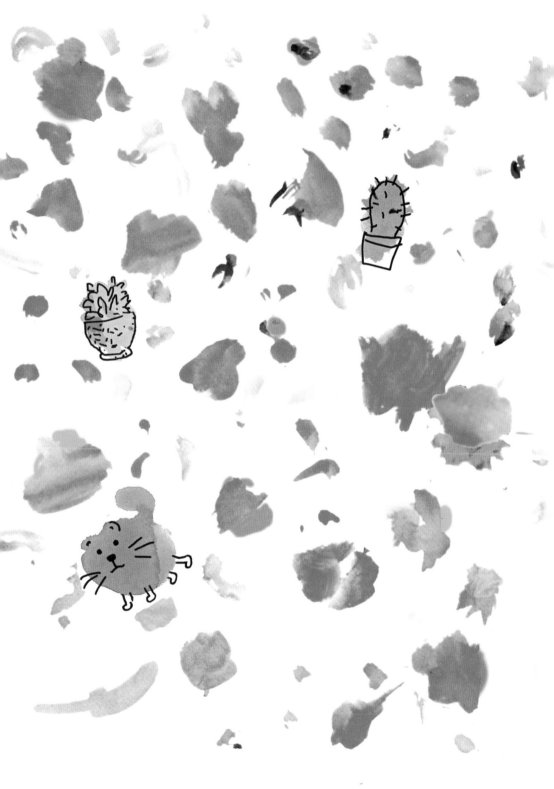

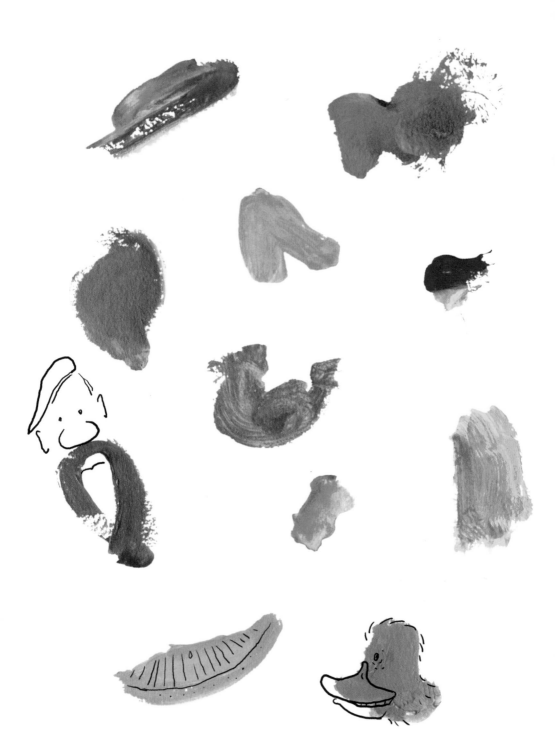

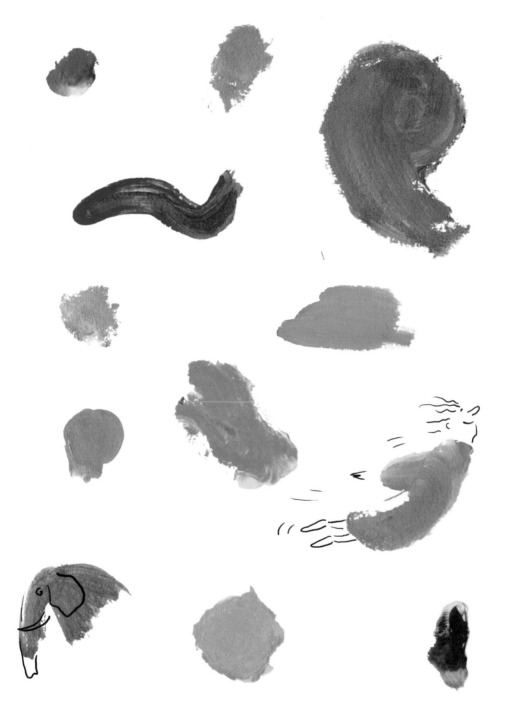

ARE THESE BIRDS OR BEES,
BEARS OR TREES?

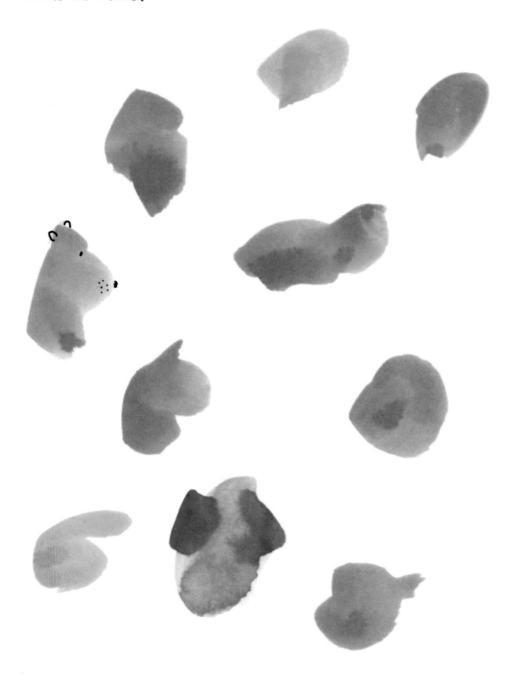

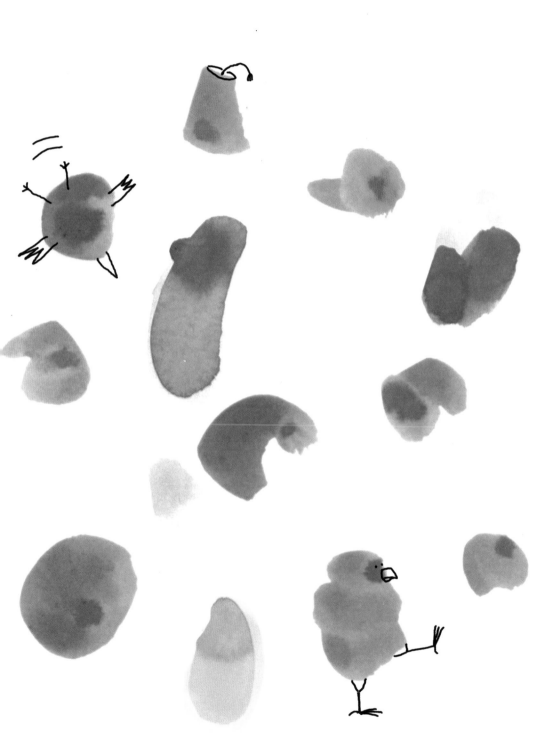

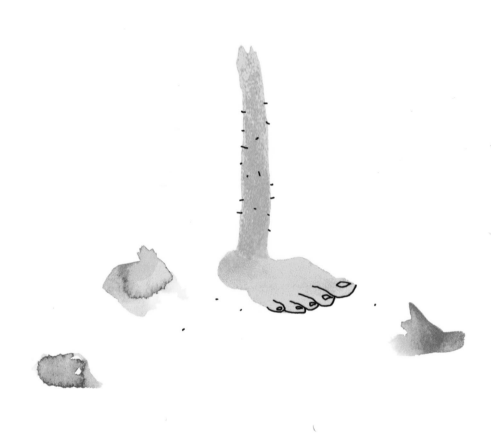

GAZE UPON EACH YELLOW BLOT
AND TURN IT INTO SOMETHING: WHAT?

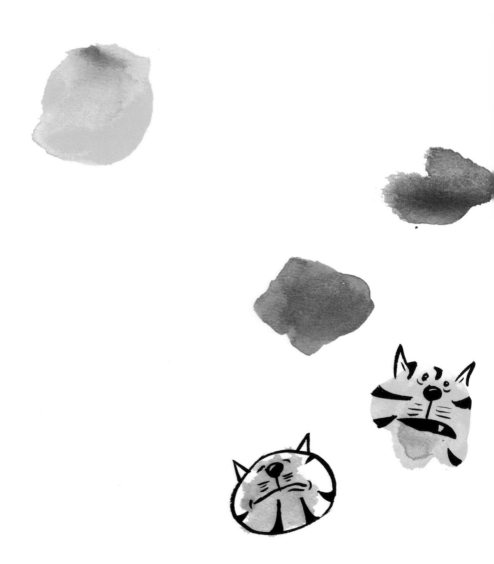

HIRAMEKI

STEP 2

COLLECTIONS

LOTS OF BLOTS, ONE SUBJECT AT A TIME

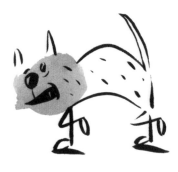

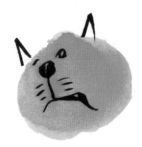

WHISKERS CAN TURN BLOT TO CAT.
BUT CAT TO TIGER - WHAT DOES THAT?

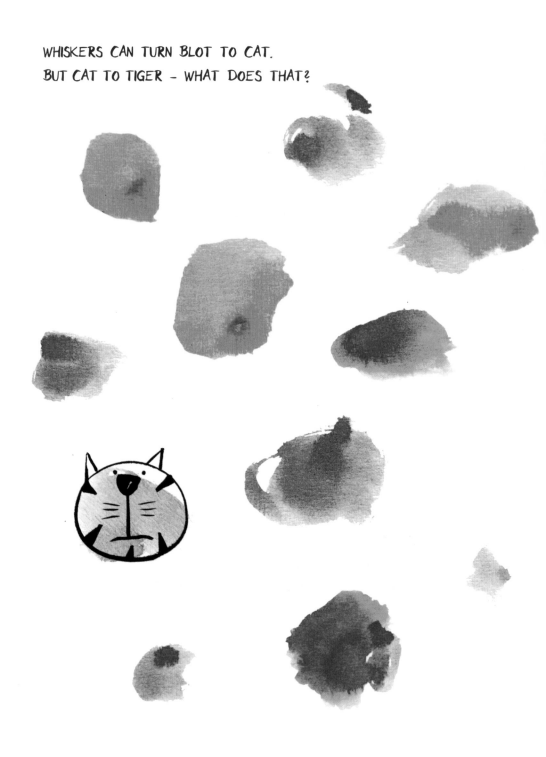

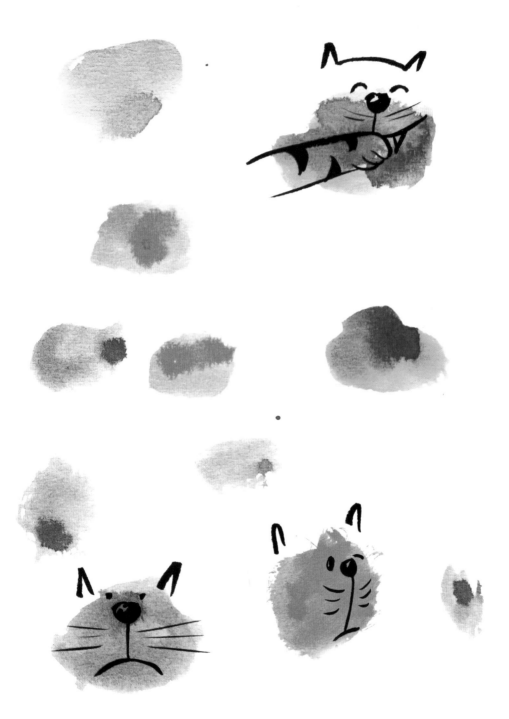

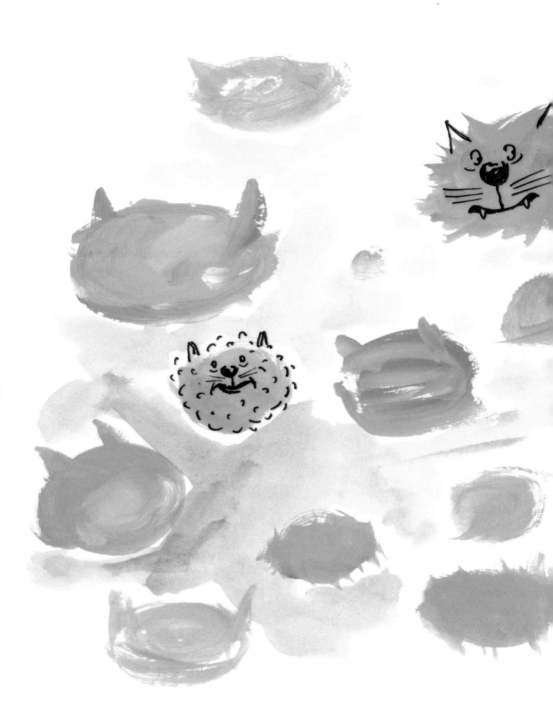

FUZZIER BLOTS MAKE FLUFFIER CATS.

A BIRD LIKES TO FLAP ITS WINGS...
...OR ELSE IT HOPS ABOUT AND SINGS.

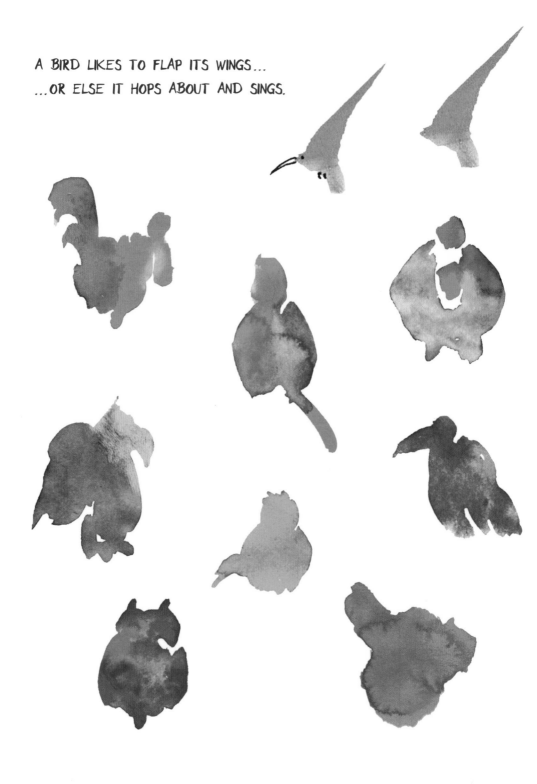

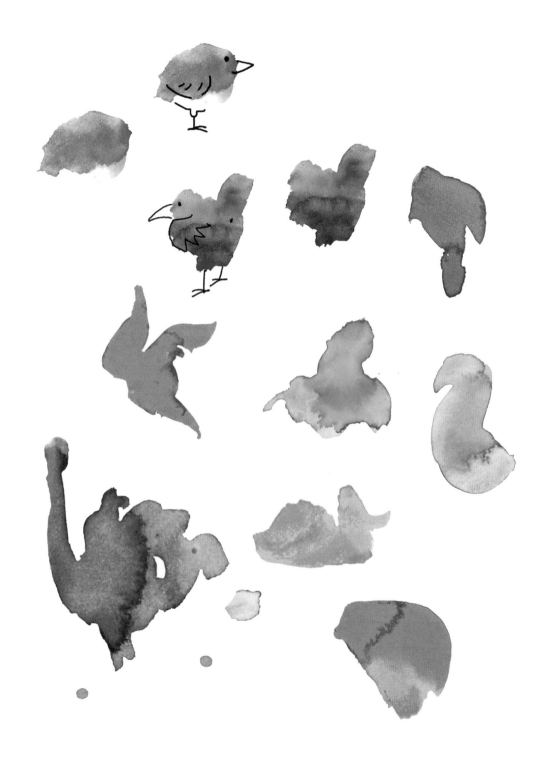

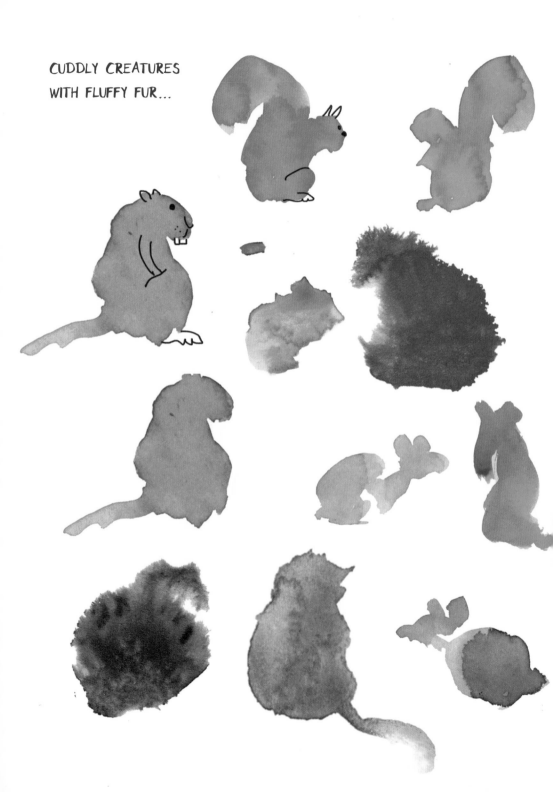

CUDDLY CREATURES
WITH FLUFFY FUR...

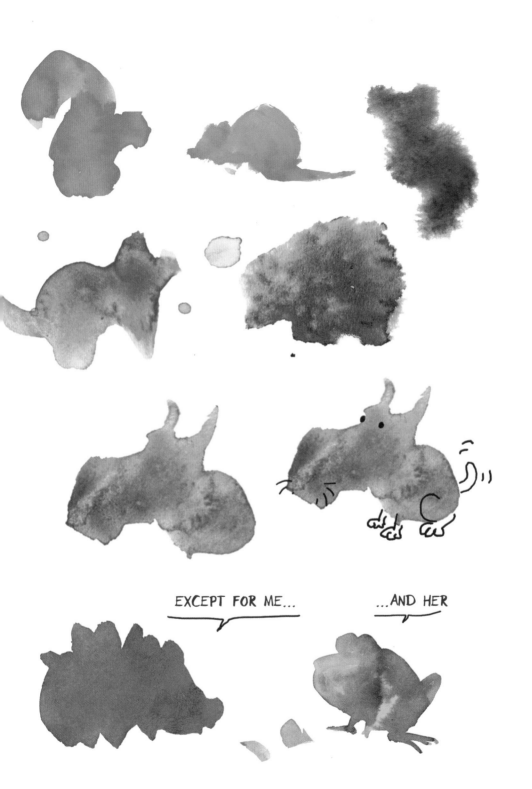

EXCEPT FOR ME...

...AND HER

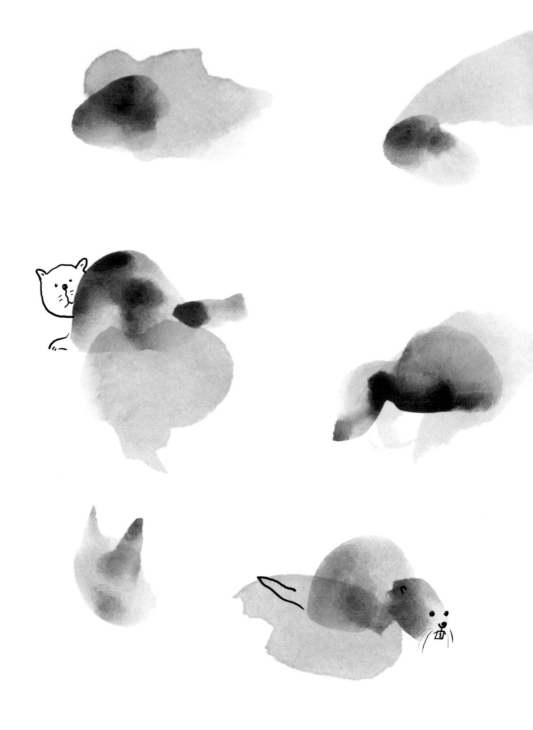

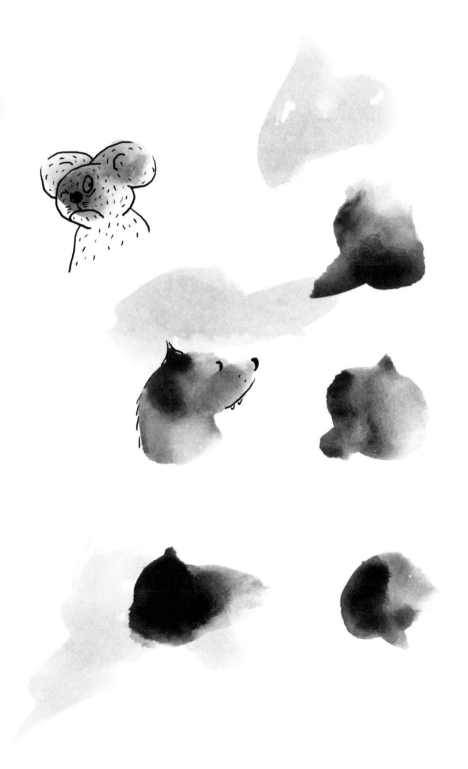

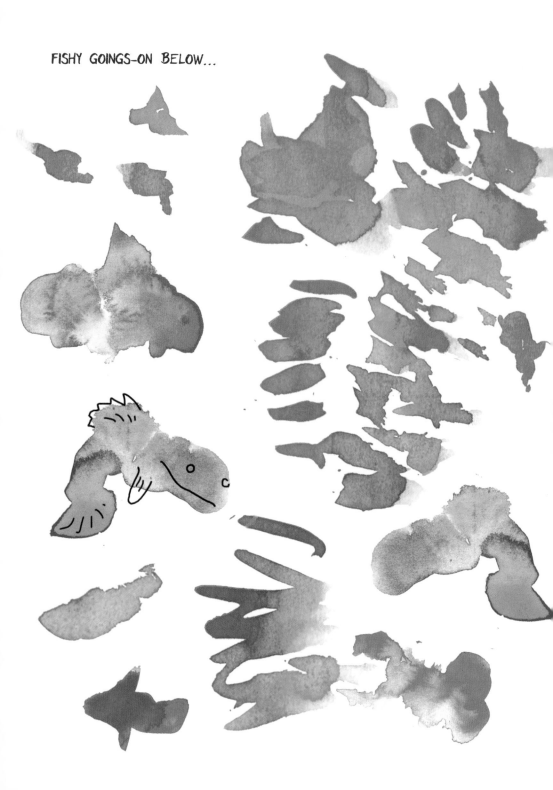

FISHY GOINGS-ON BELOW...

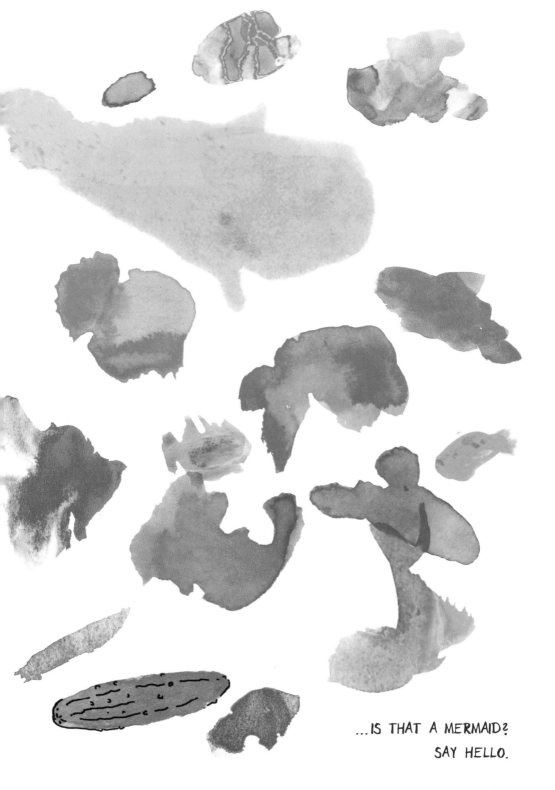

...IS THAT A MERMAID?
SAY HELLO.

A PACK OF DOGS TO DOODLE...

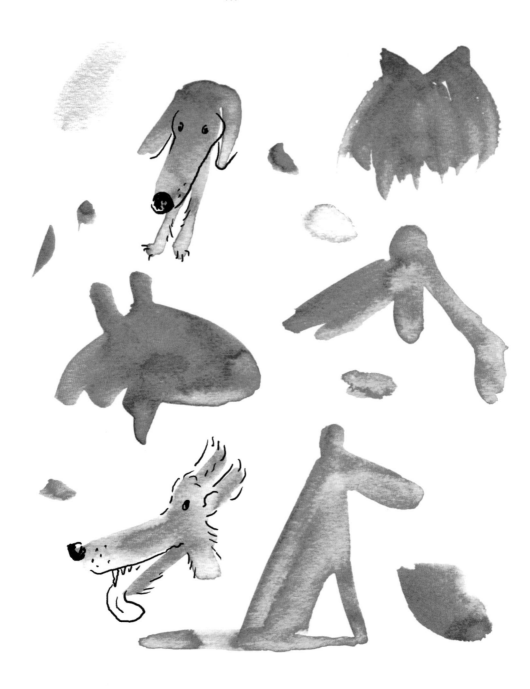

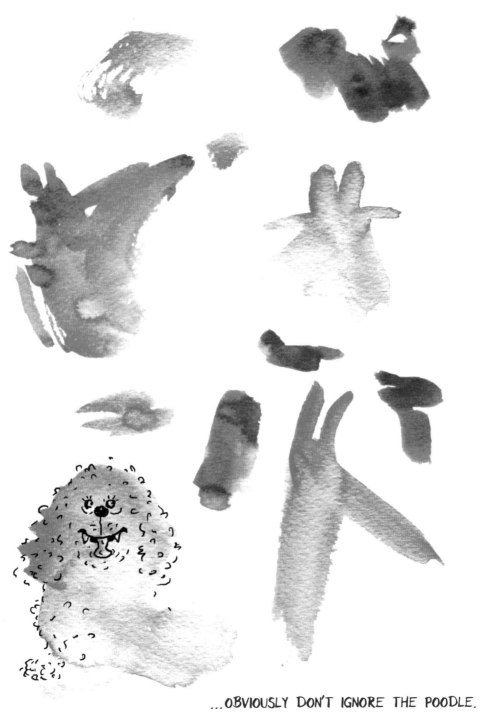

...OBVIOUSLY DON'T IGNORE THE POODLE.

EVERY SORT OF HOUSEHOLD GADGET...

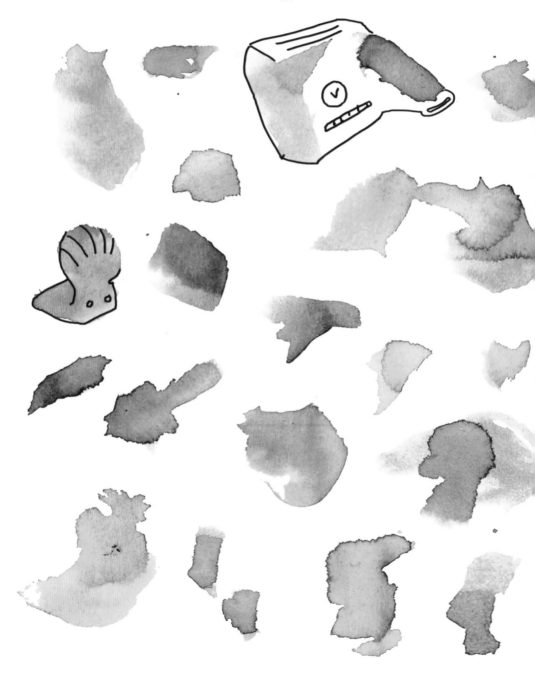

...IF IT SPARKS, BETTER UNPLUG IT.

FUNKY FURNITURE, STYLISH KIT...

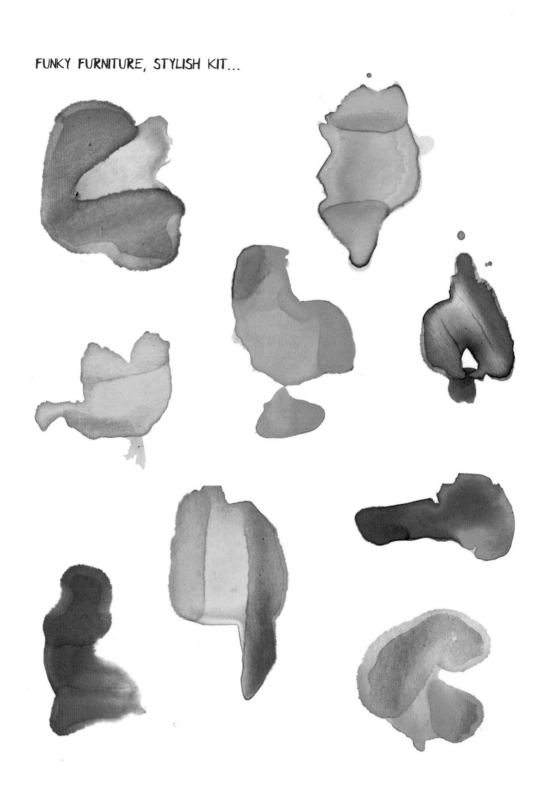

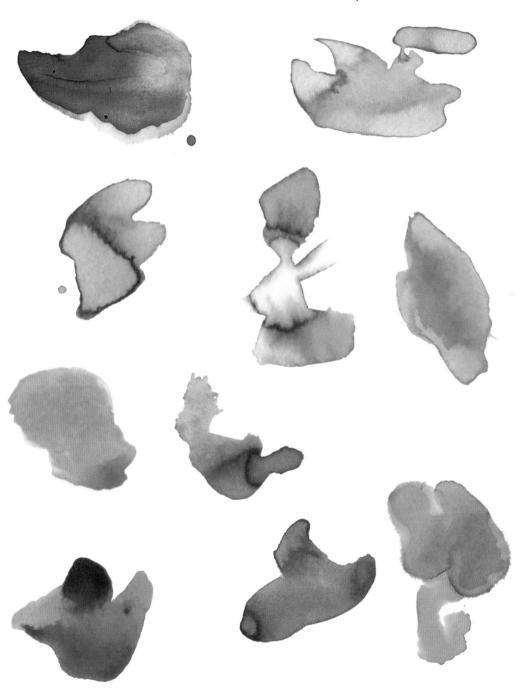

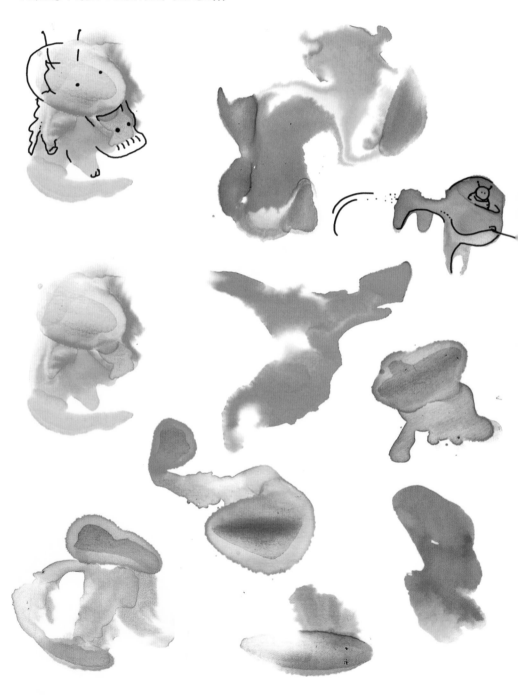

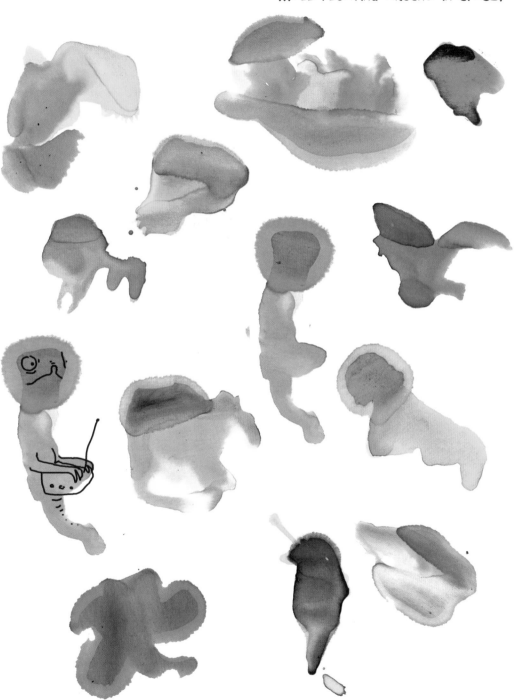

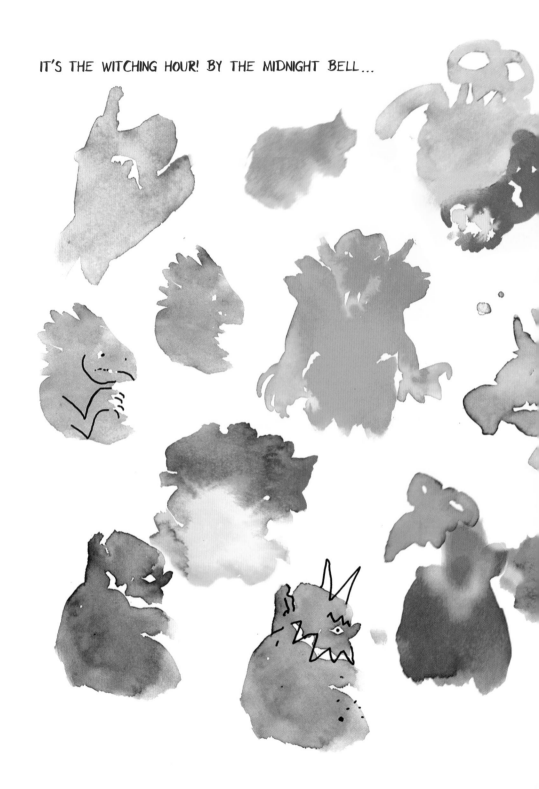

IT'S THE WITCHING HOUR! BY THE MIDNIGHT BELL...

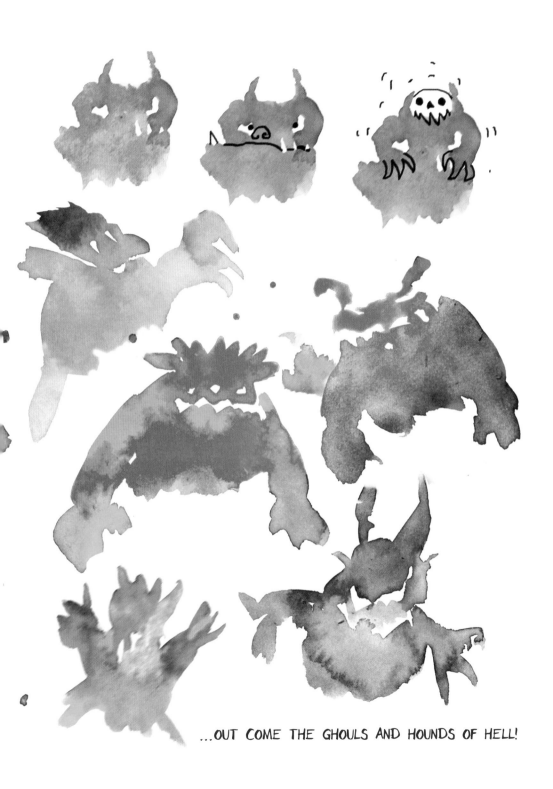

...OUT COME THE GHOULS AND HOUNDS OF HELL!

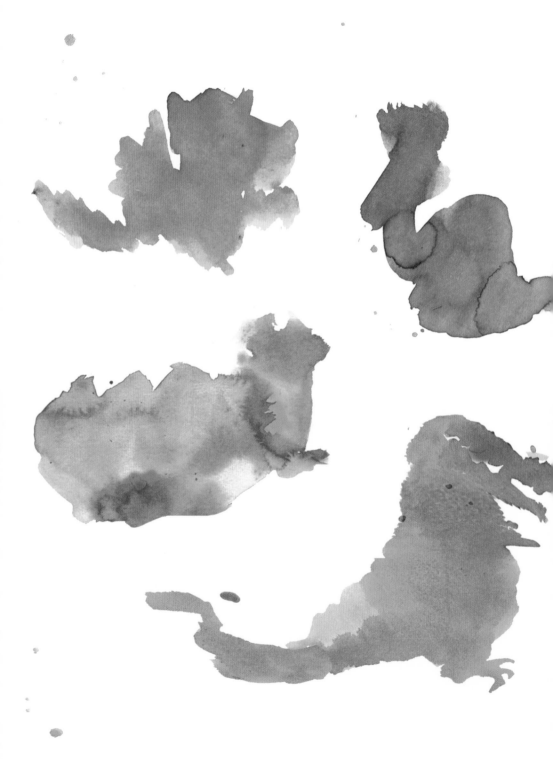

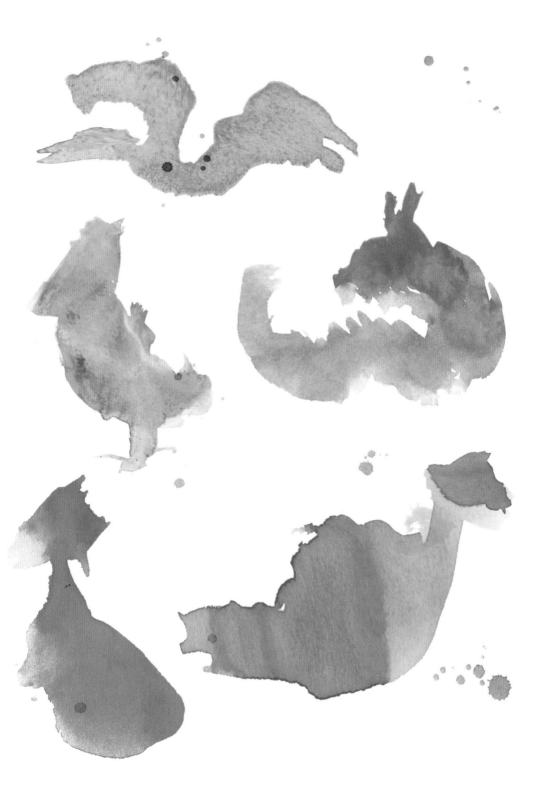

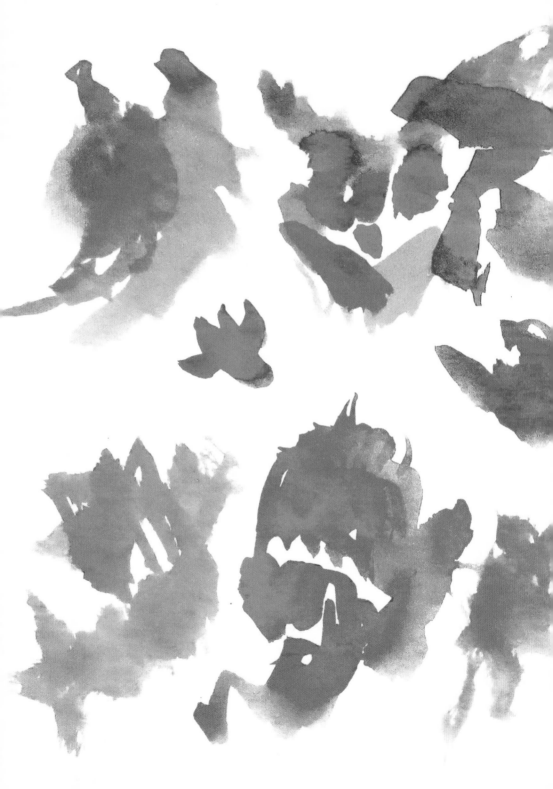

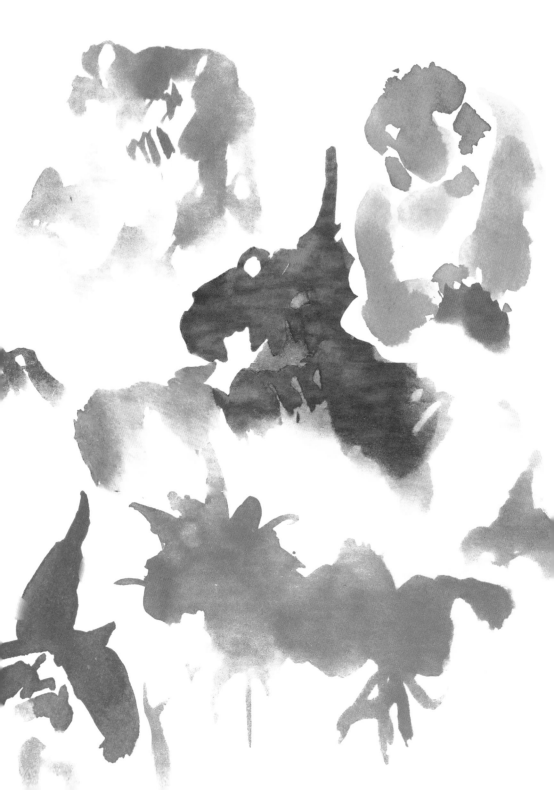

TWITTER - SCREECH - FLUTTER...CLUCK
BEAKY CREATURES AND A DUCK

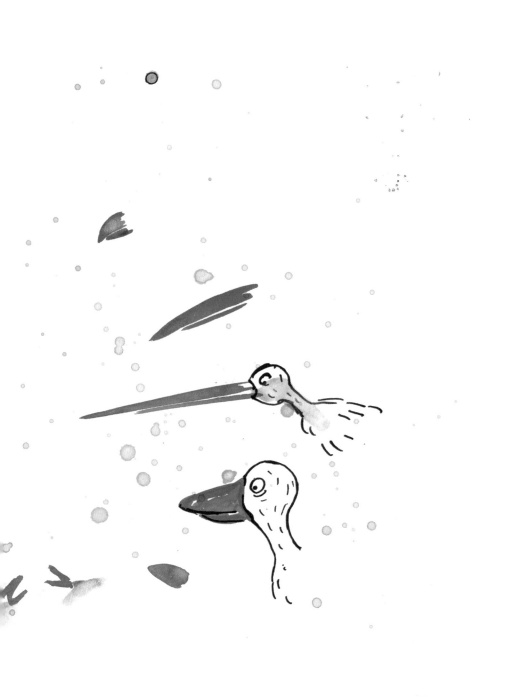

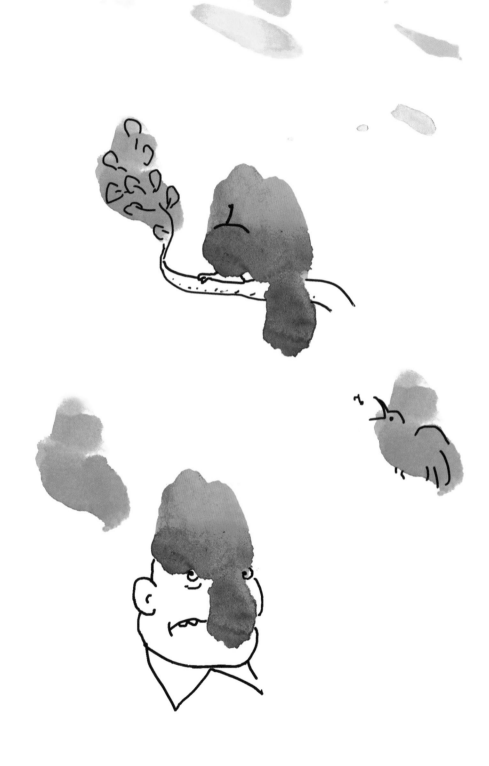

HIRAMEKI

STEP 3

VARIATIONS

ONE BLOT, MANY SUBJECTS

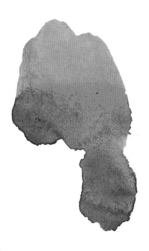

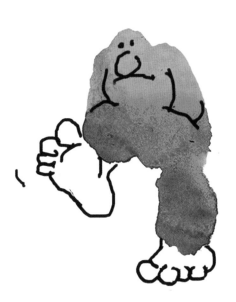

TWELVE VIEWS OF A MOUNTAIN PEAK...

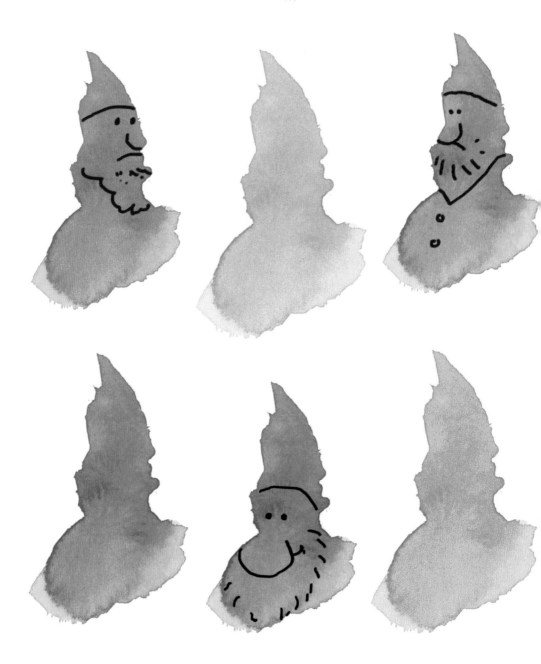

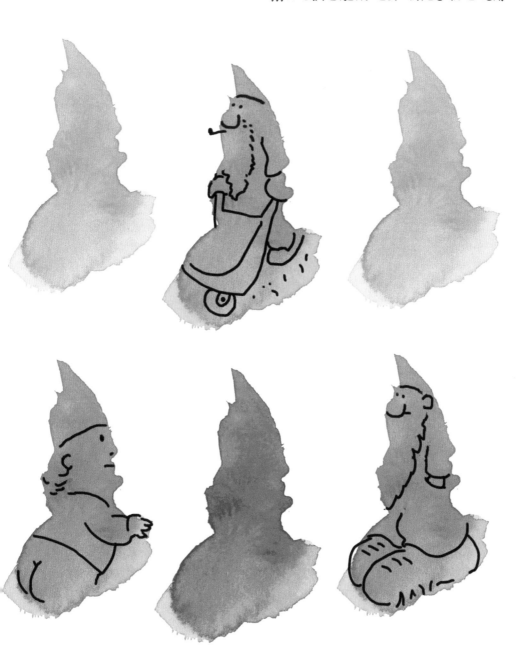

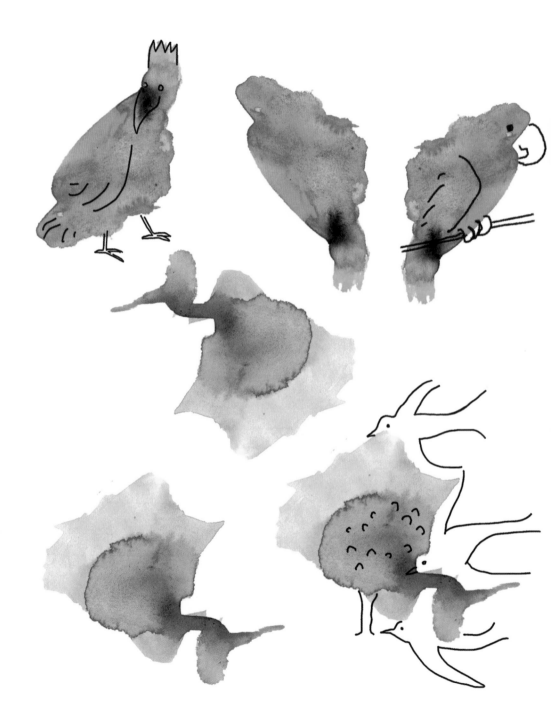

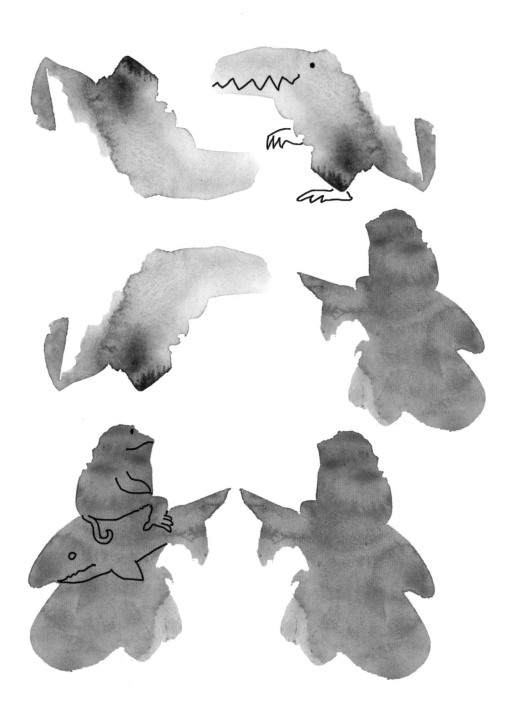

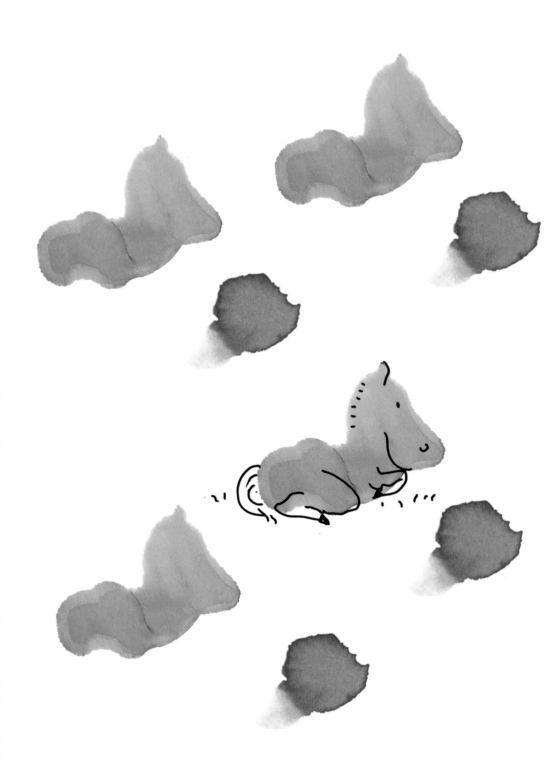

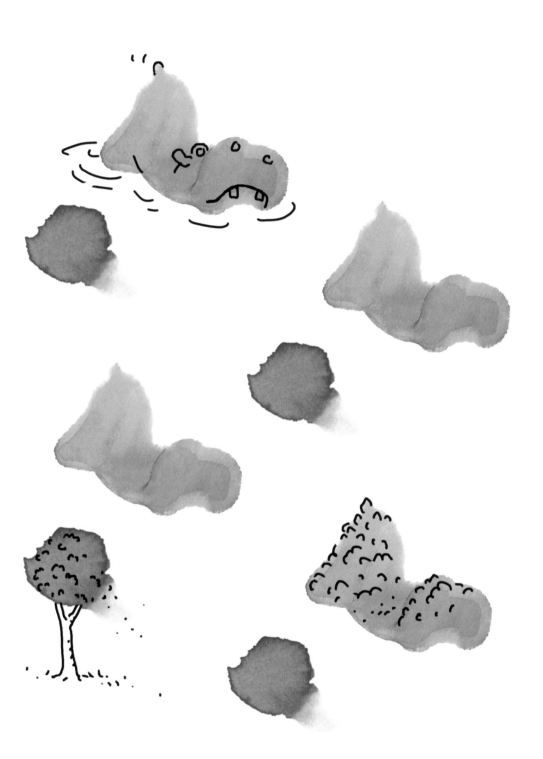

IS IT A FACE, IS IT A PIG?

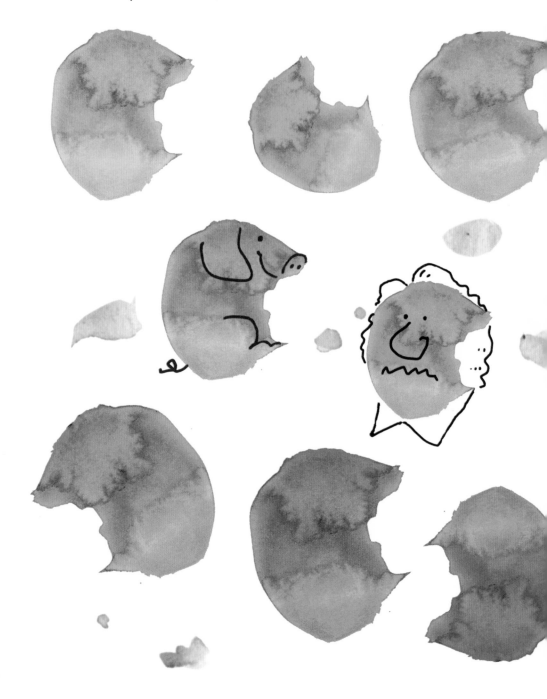

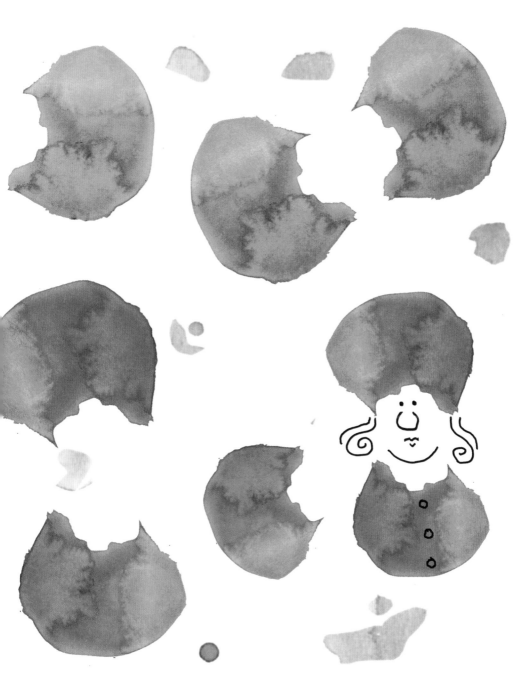

OR IS IT A VERY BOUFFANT WIG?

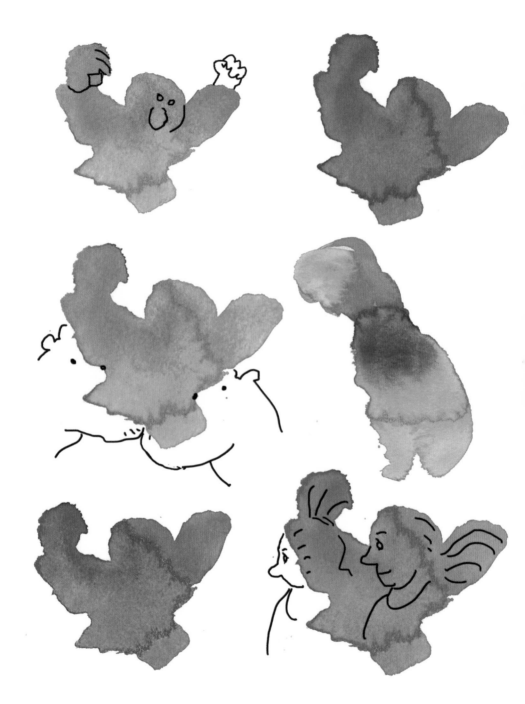

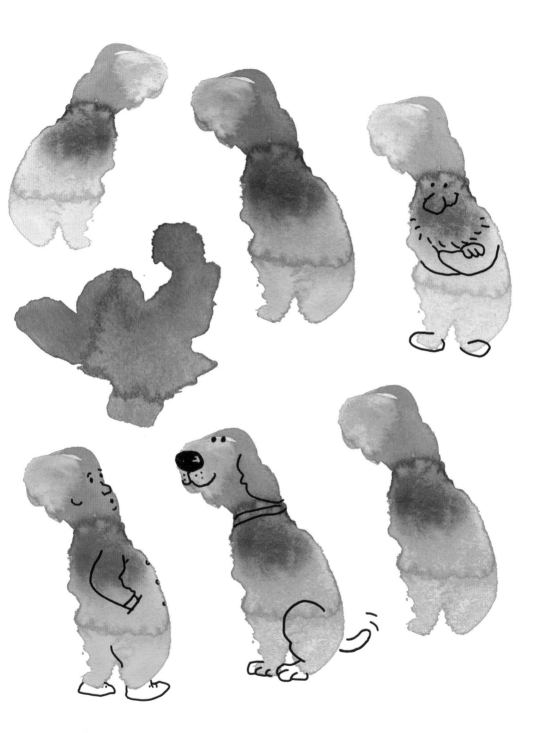

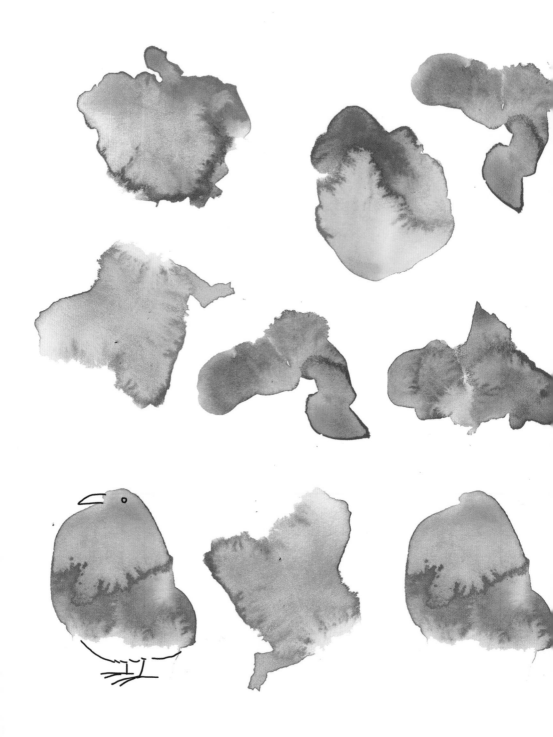

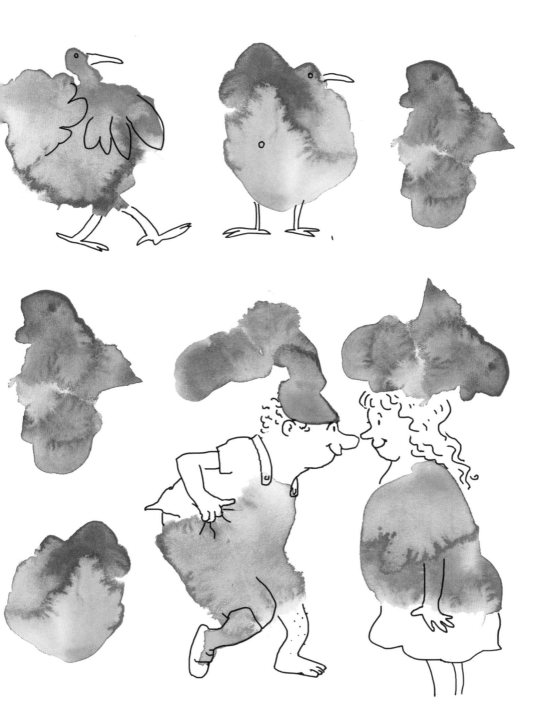

A HEN, A GLOVE, A HAIRY MAN...

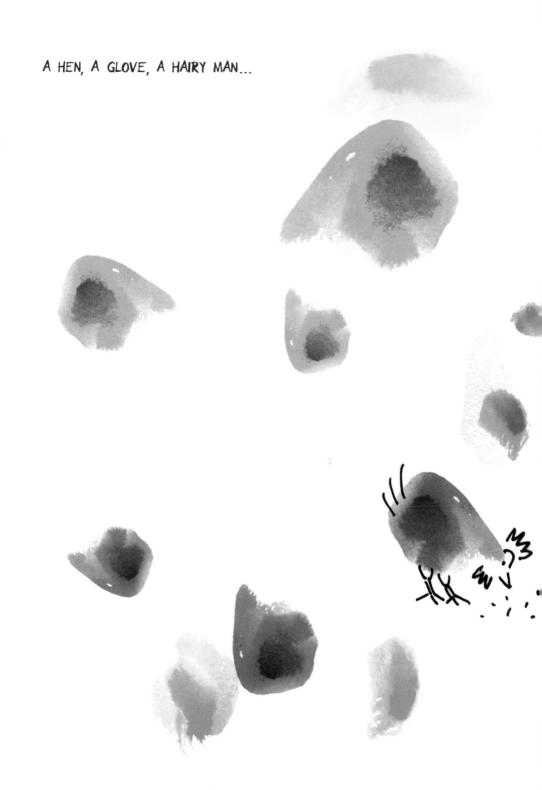

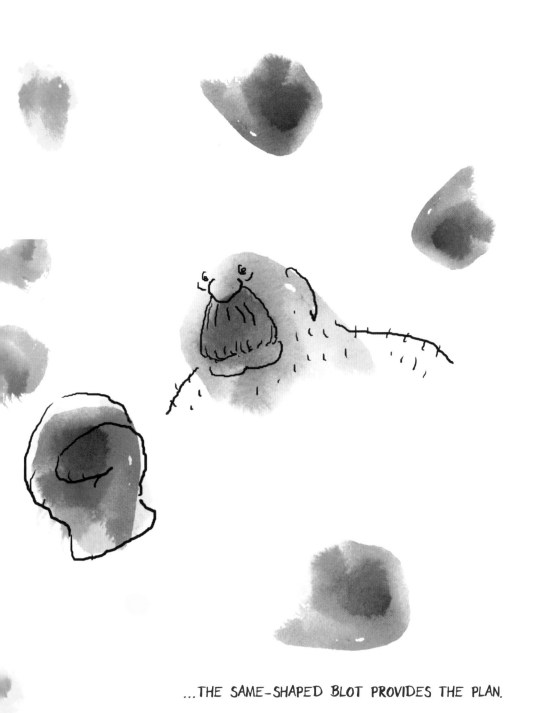

...THE SAME-SHAPED BLOT PROVIDES THE PLAN.

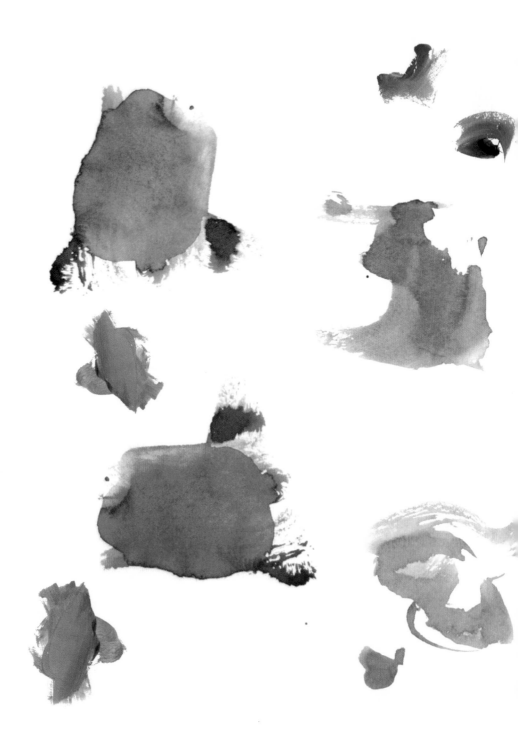

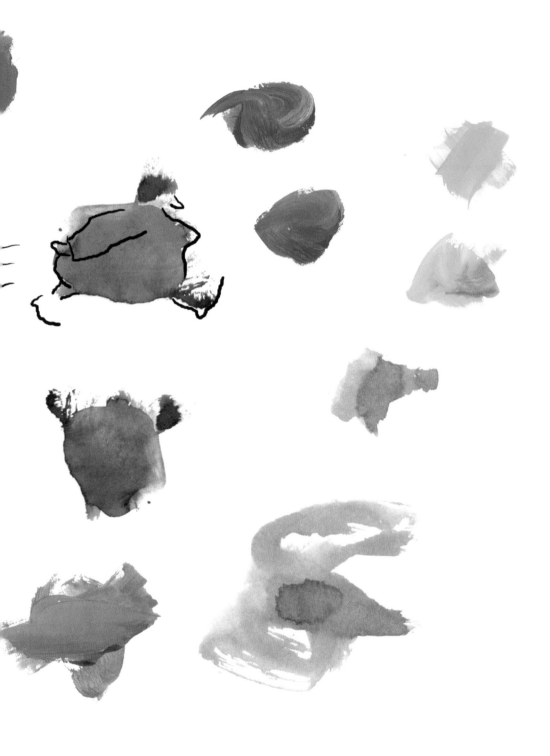

THE SKIRT BILLOWS IN THE BREEZE...

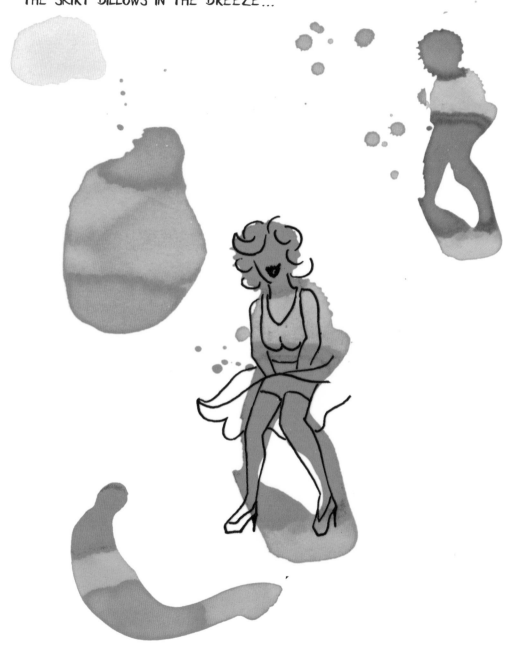

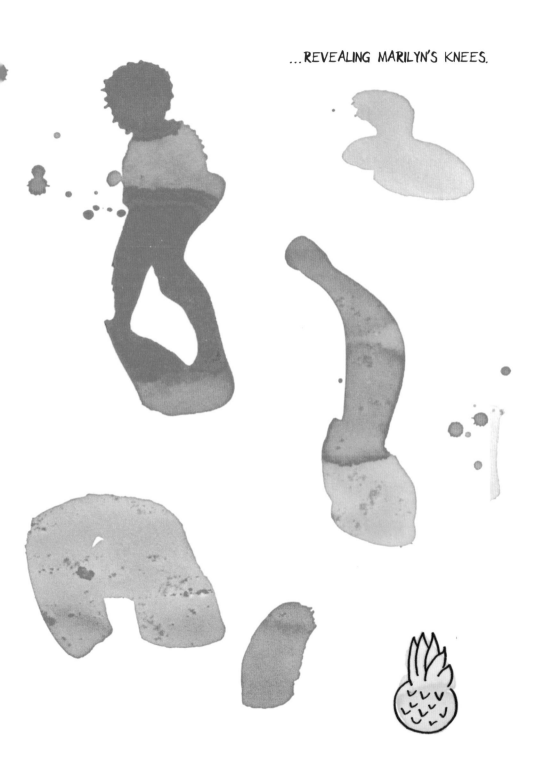

...REVEALING MARILYN'S KNEES.

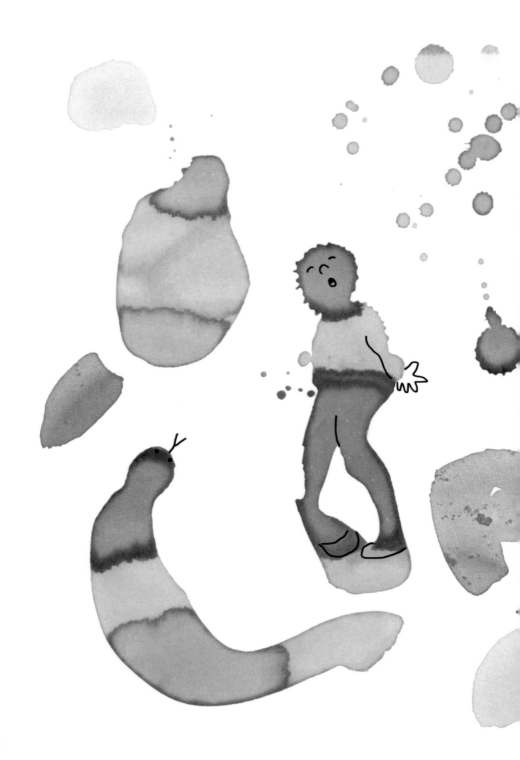

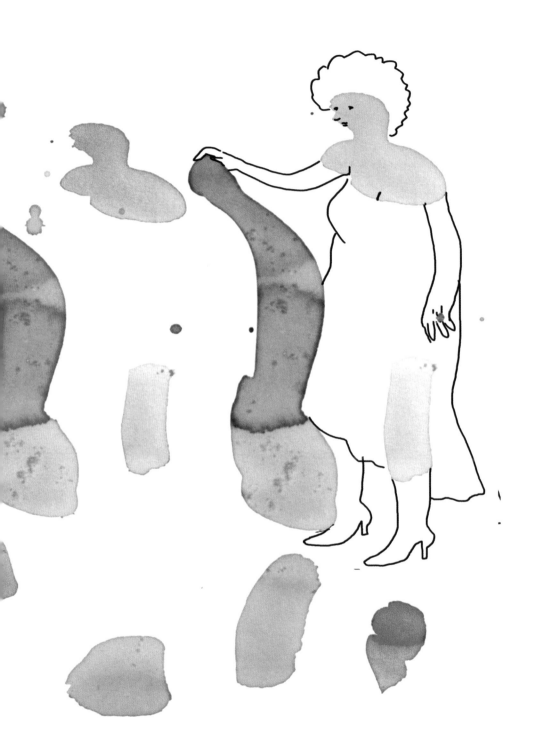

CRABS SCRABBLE ALONG THE BEACH
LOTS OF BOTTLES, A MESSAGE IN EACH

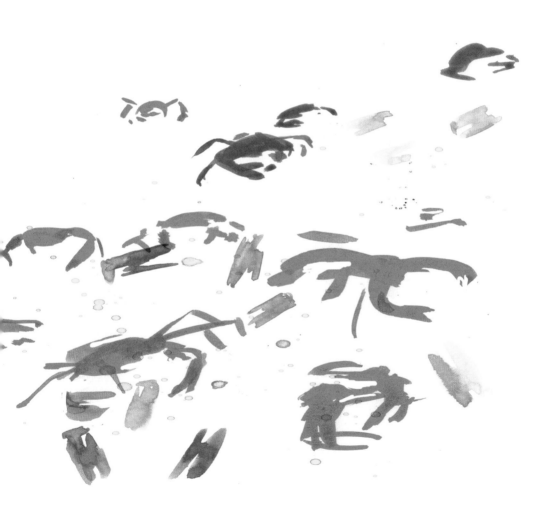

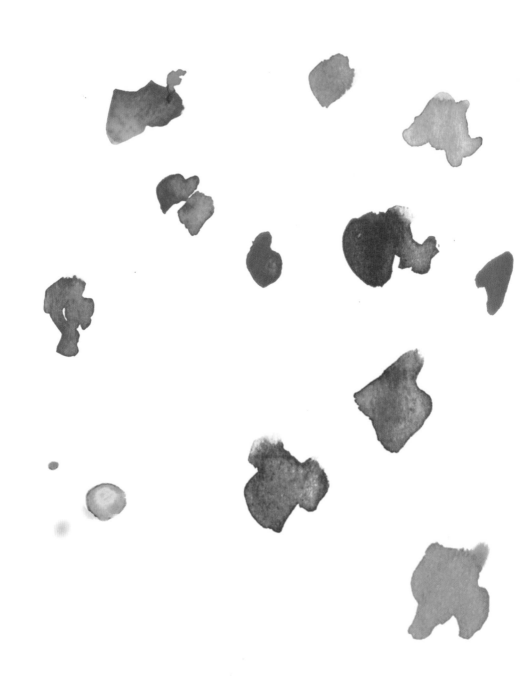

HIRAMEKI

STEP 4

ADDITIONS

THINKING OUTSIDE THE BLOTS

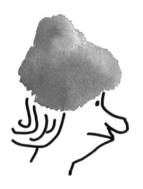

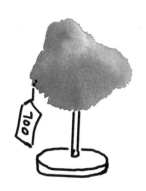

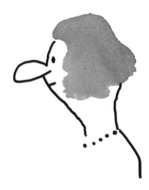

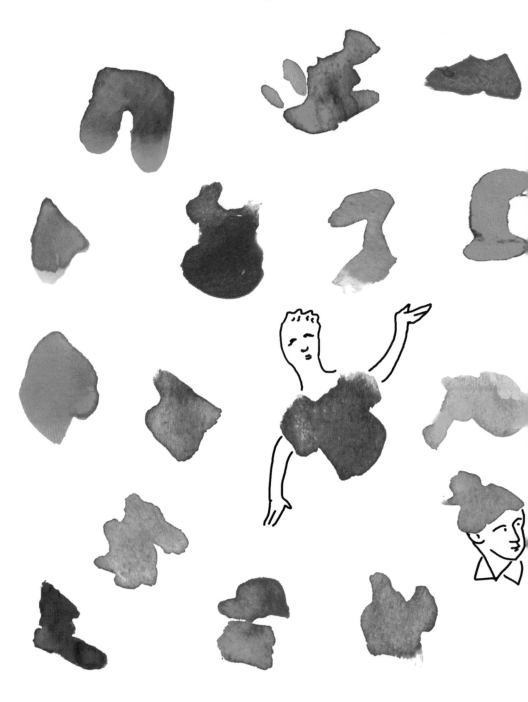

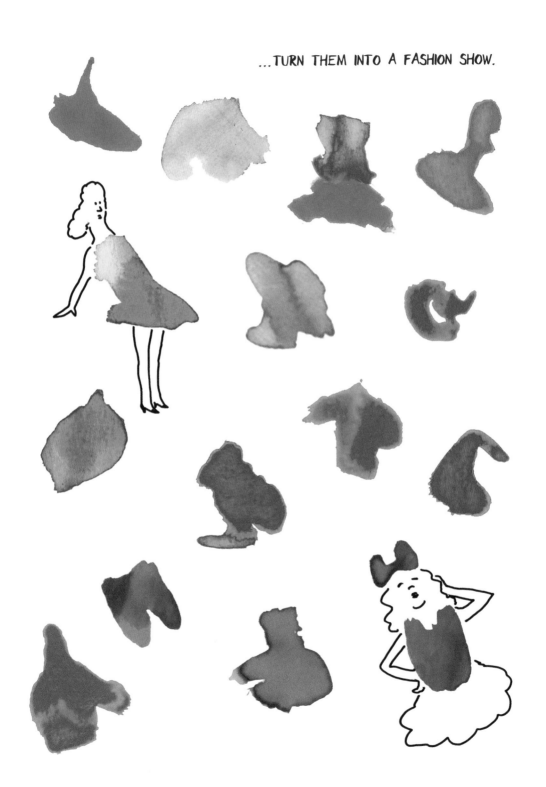

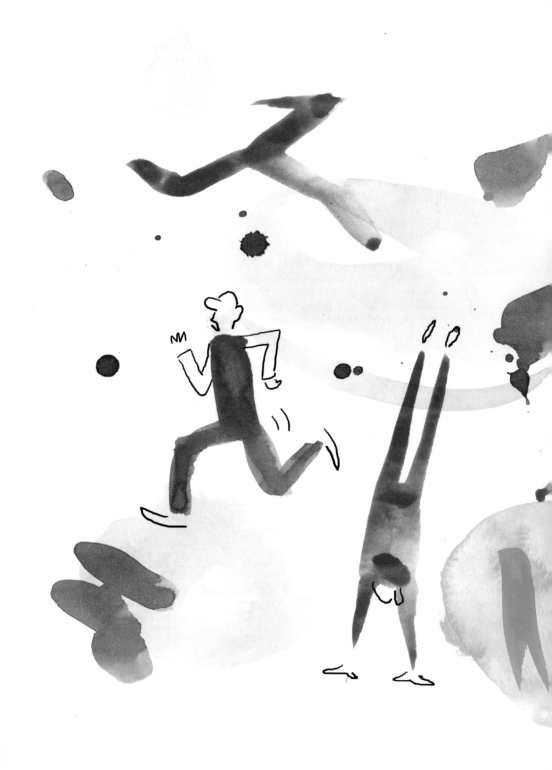

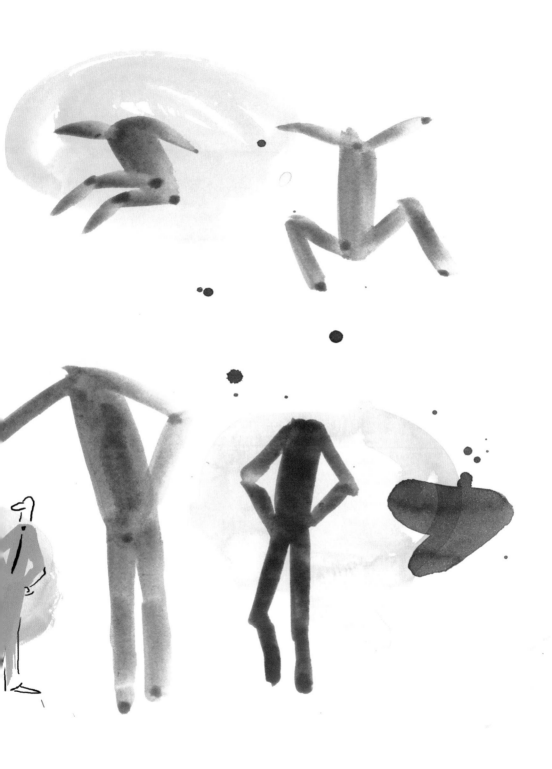

TIME FOR YOUR DANCE CLASS — ON YOUR TOES!
FILL IN THE DANCERS AND STRIKE A POSE.

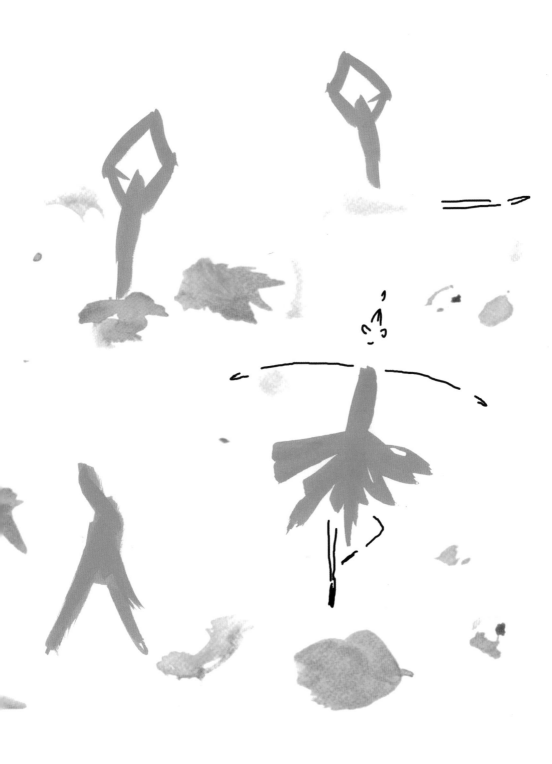

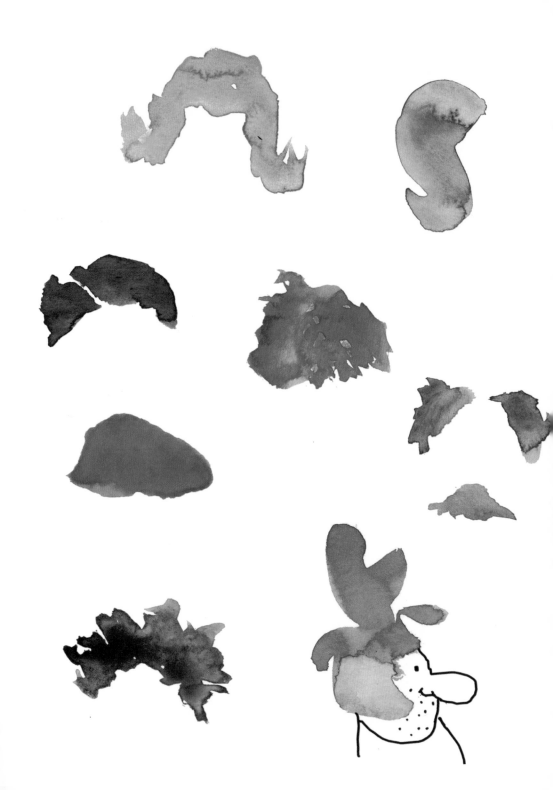

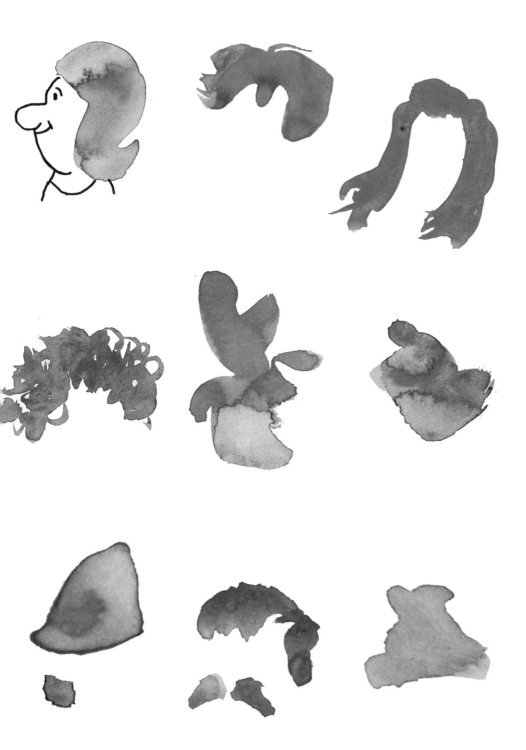

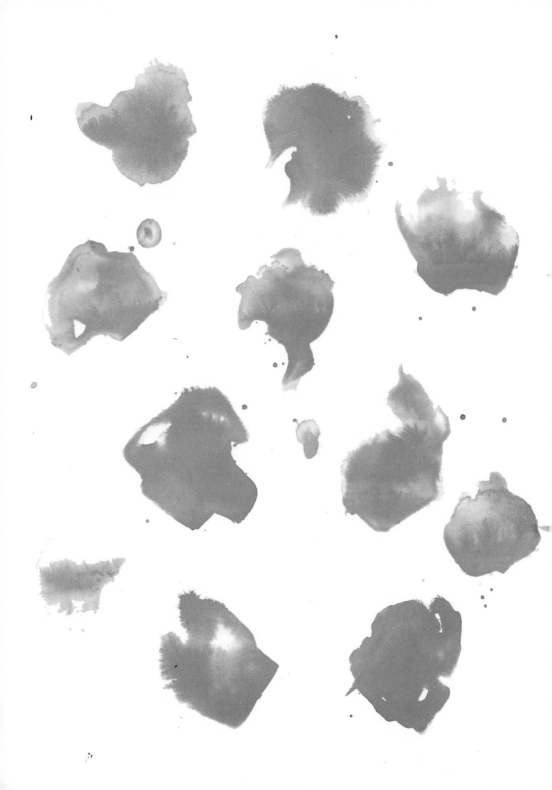

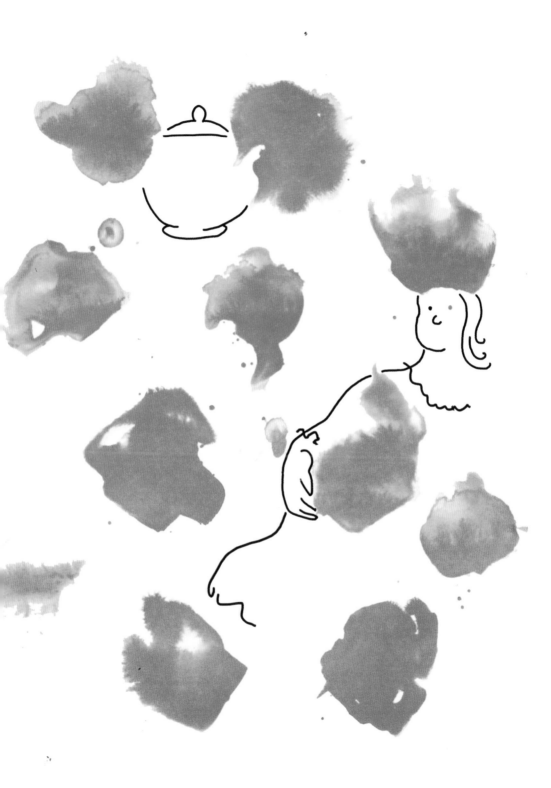

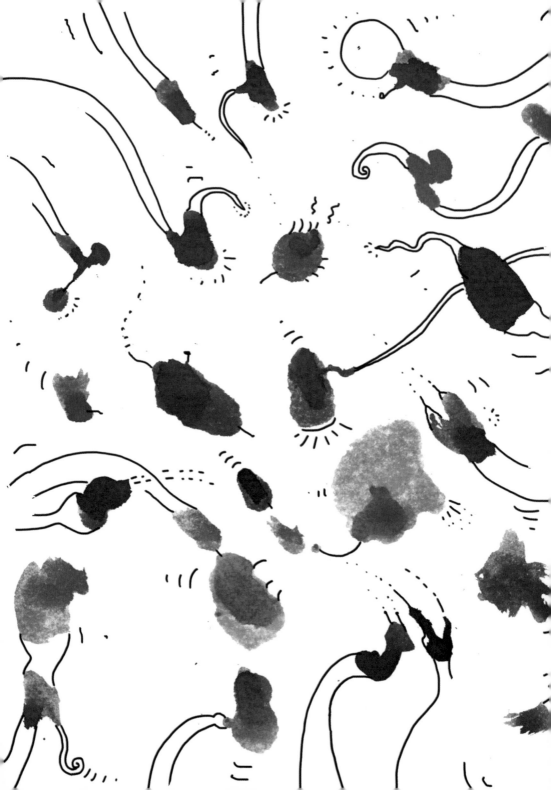

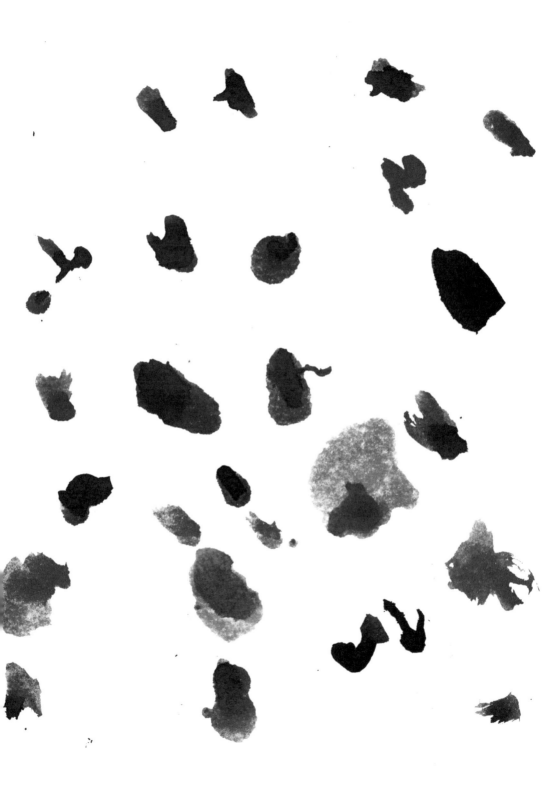

AN ANGEL HIDDEN IN THE FLOWERS...

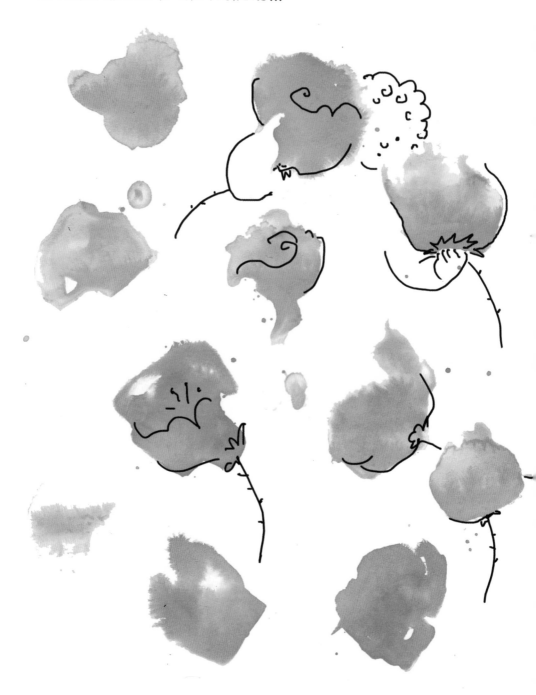

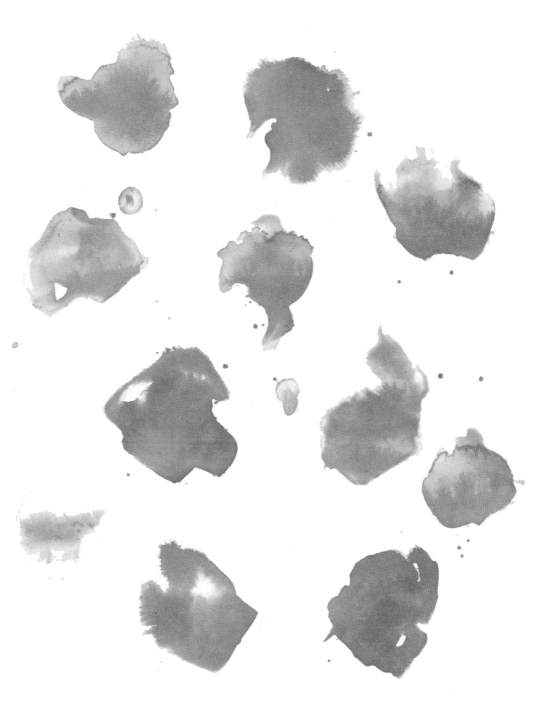

...TICKLES YOUR CREATIVE POWERS.

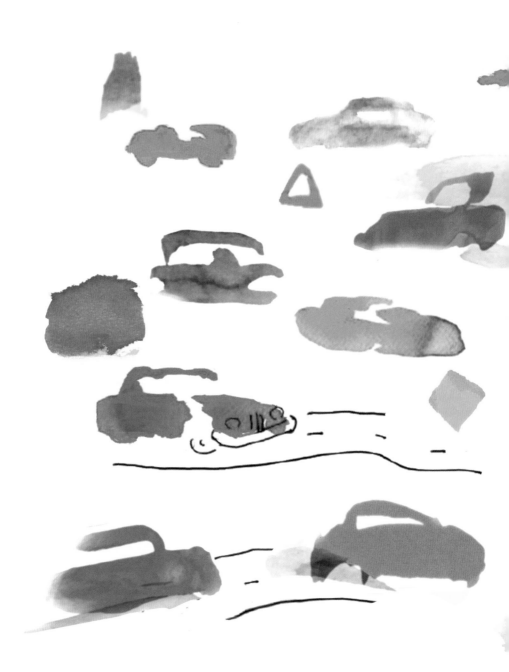

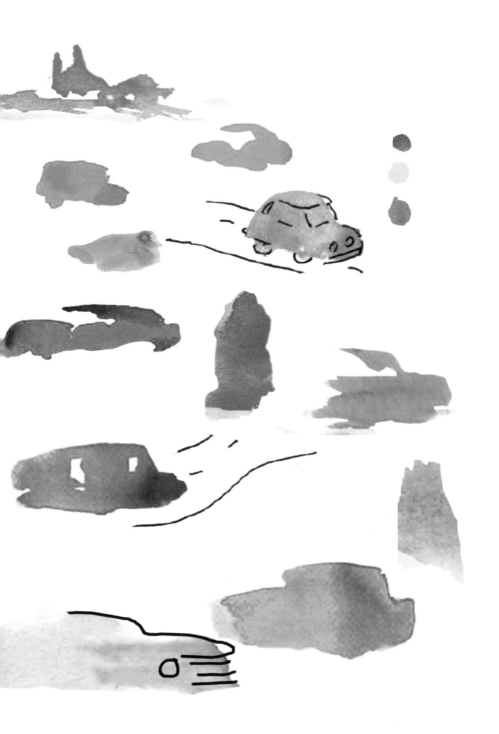

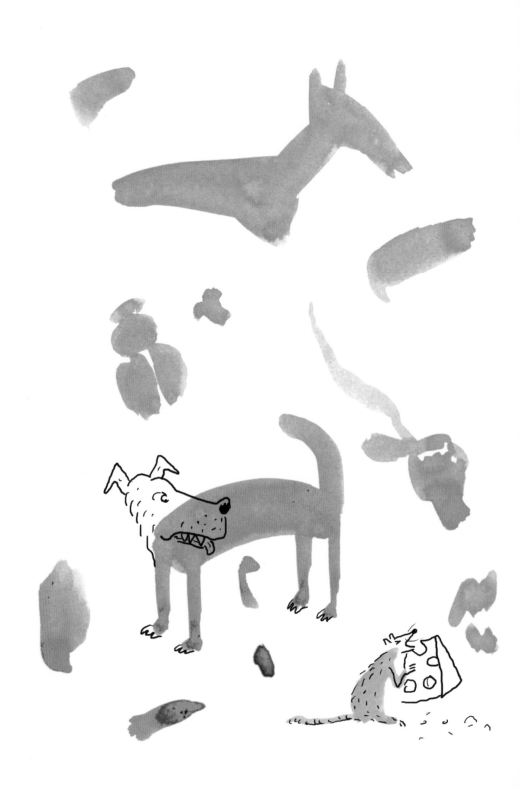

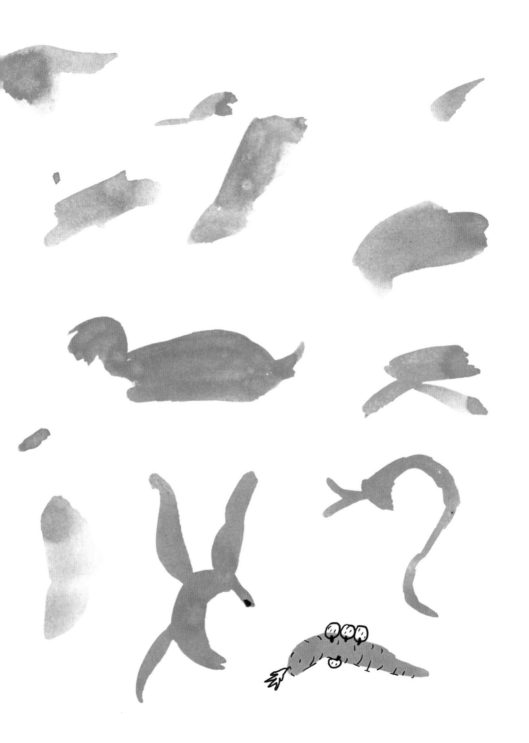

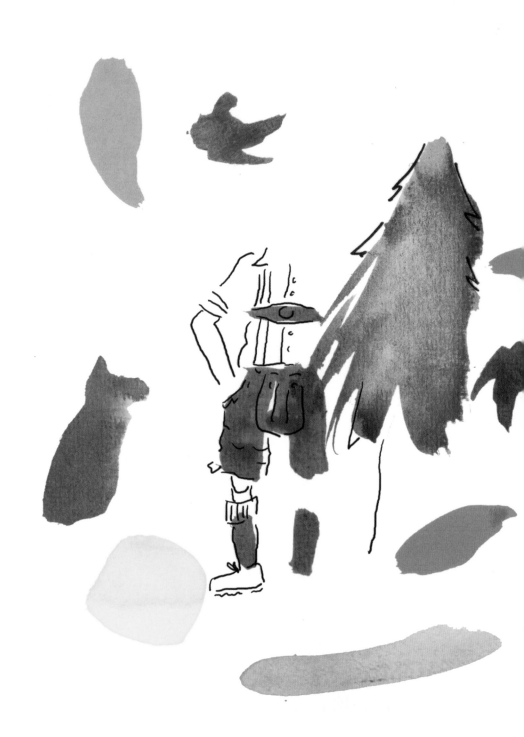

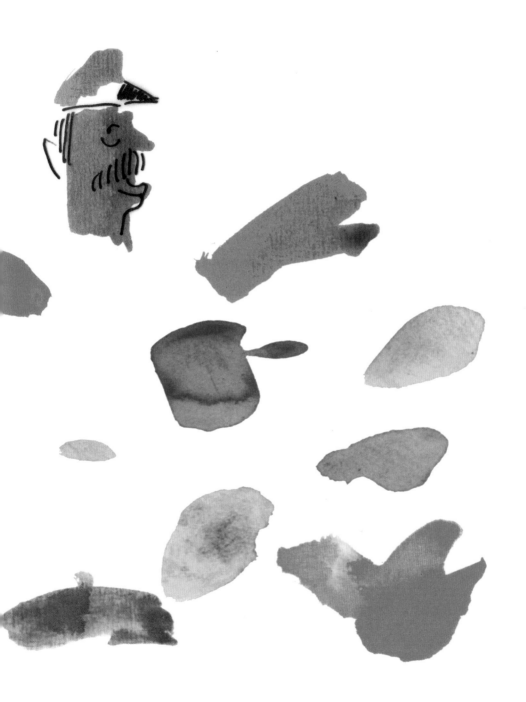

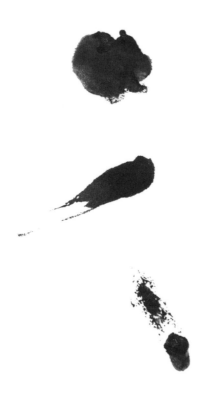

THREE BLOTS ON THIS PAGE IS PLENTY.
OPPOSITE, ANOTHER TWENTY...

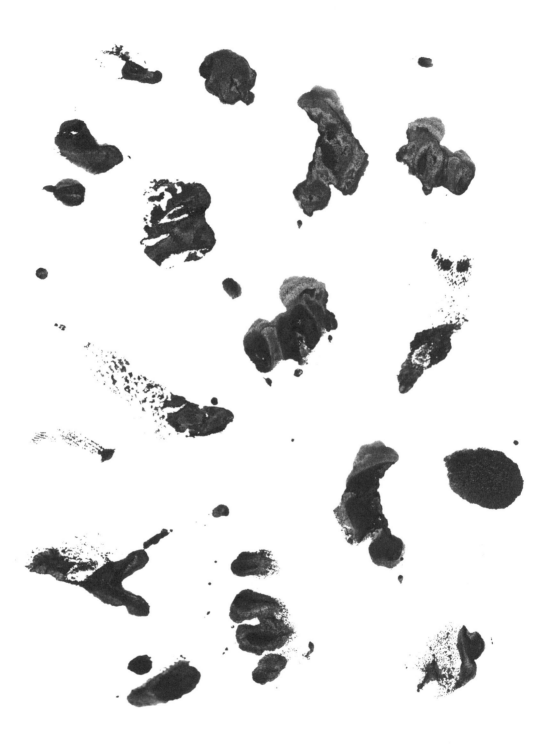

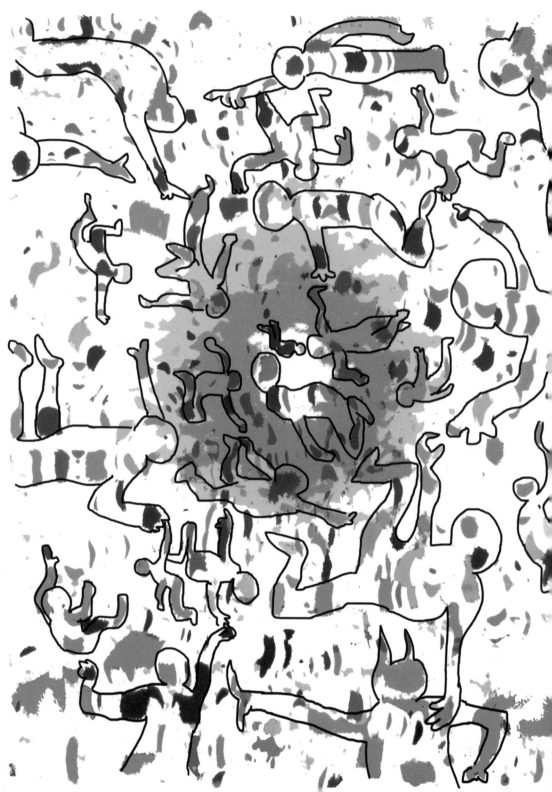

HIRAMEKI

STEP 5

COMBINATIONS

MANY BLOTS,
ONE BIG PICTURE

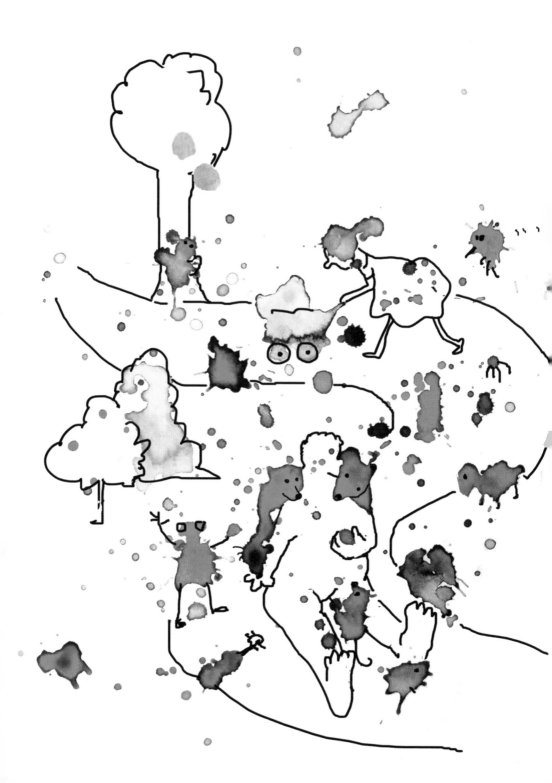

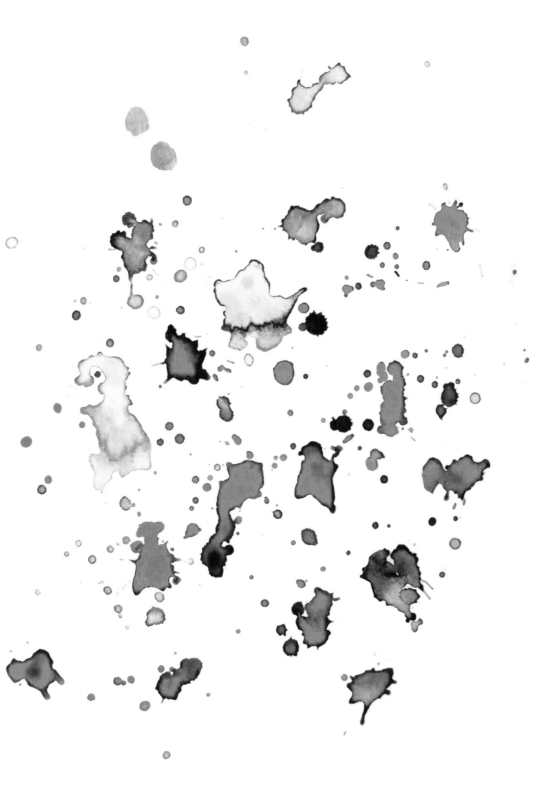

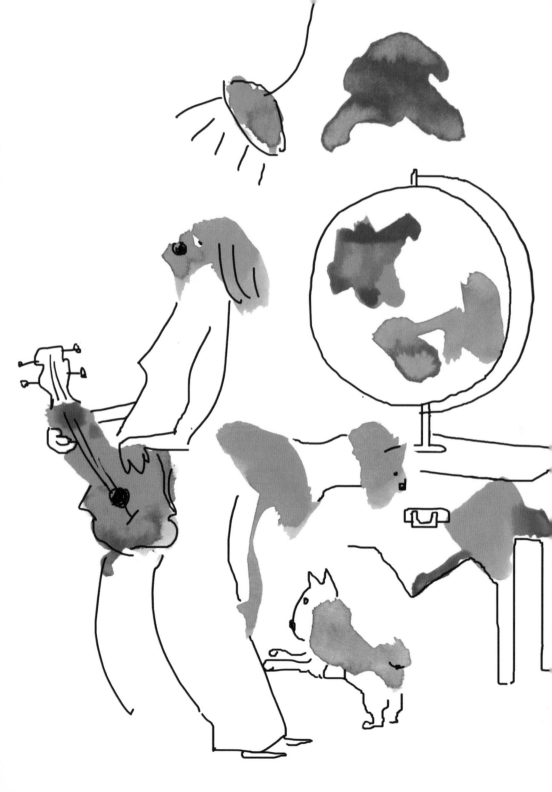

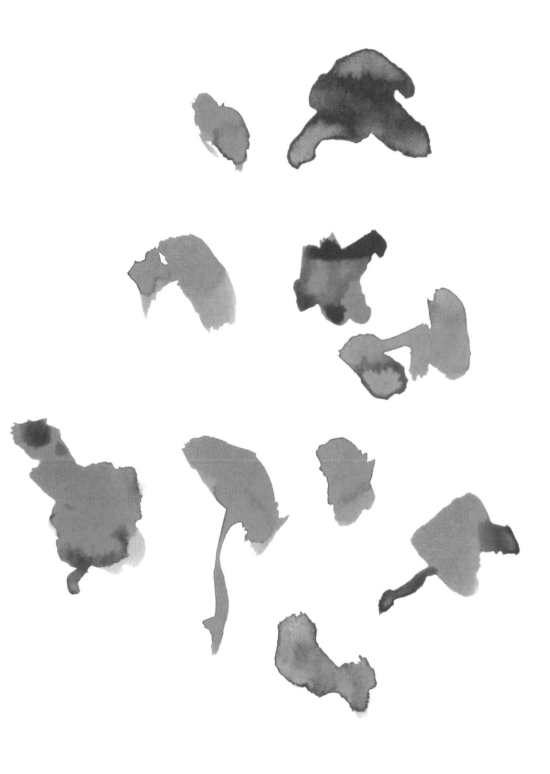

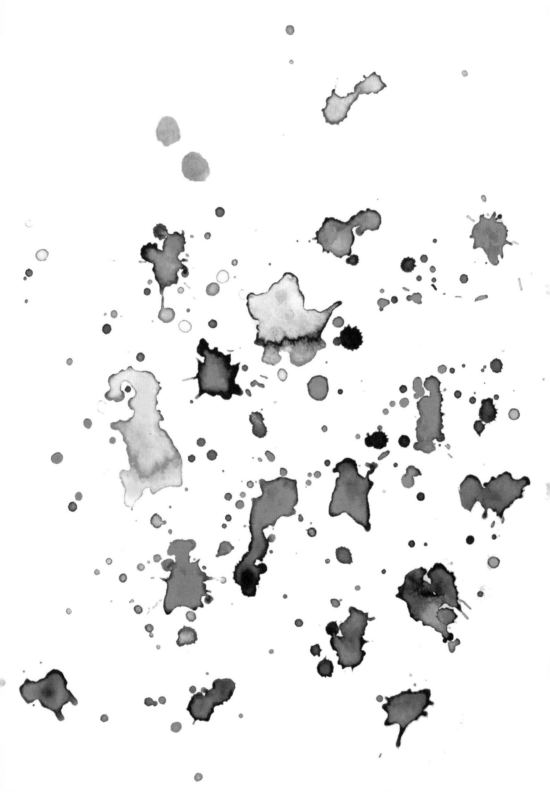

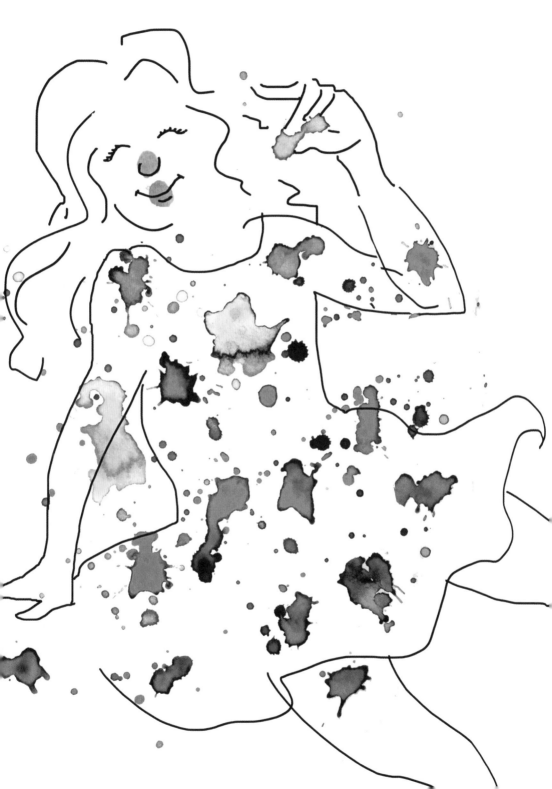

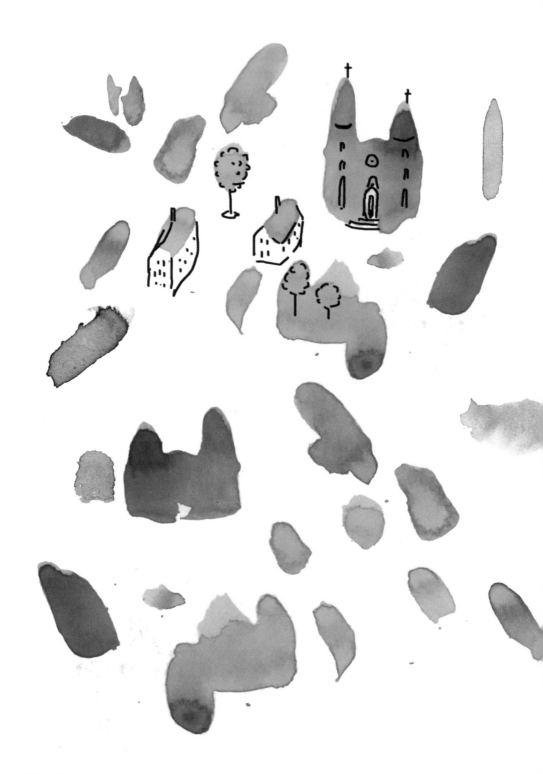

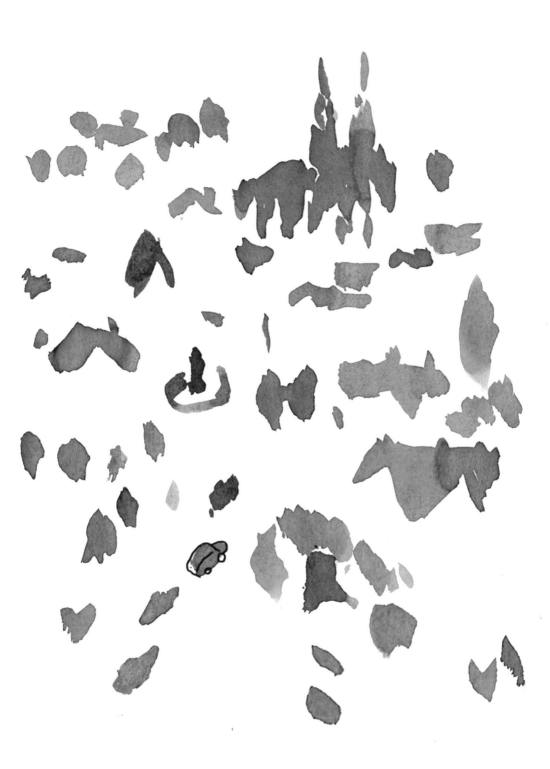

BEAUTIFUL FLOWERS OF EVERY HUE...

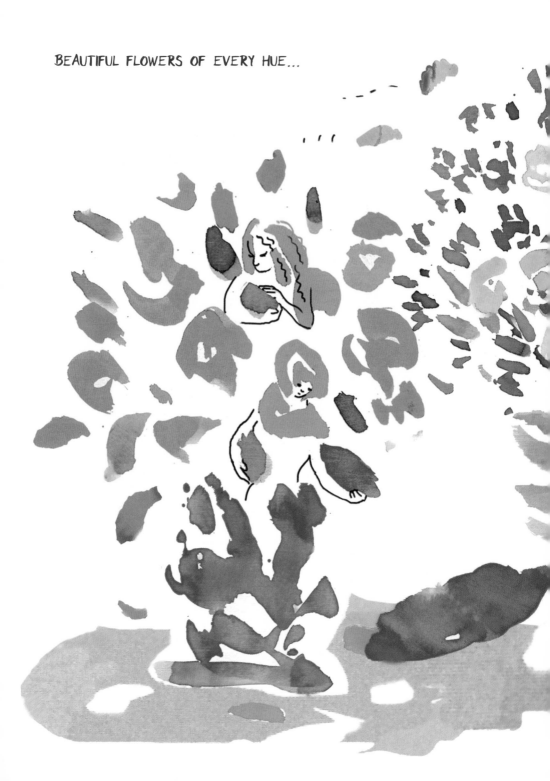

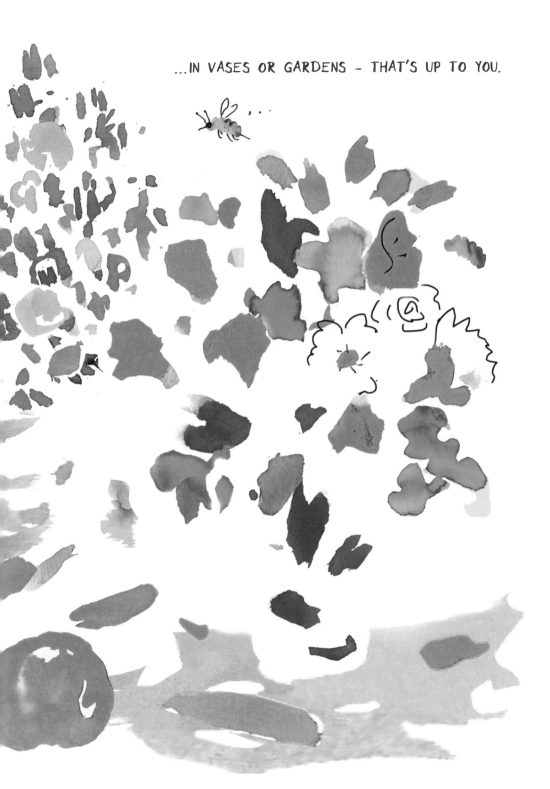

...IN VASES OR GARDENS - THAT'S UP TO YOU.

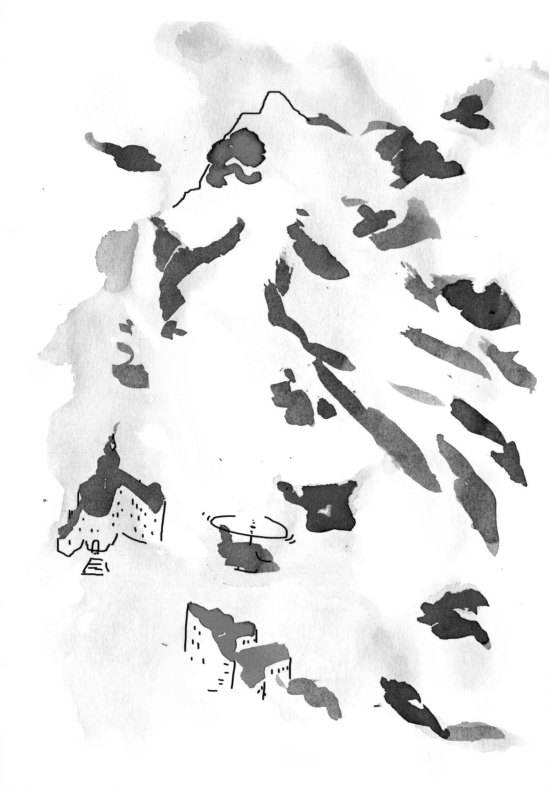

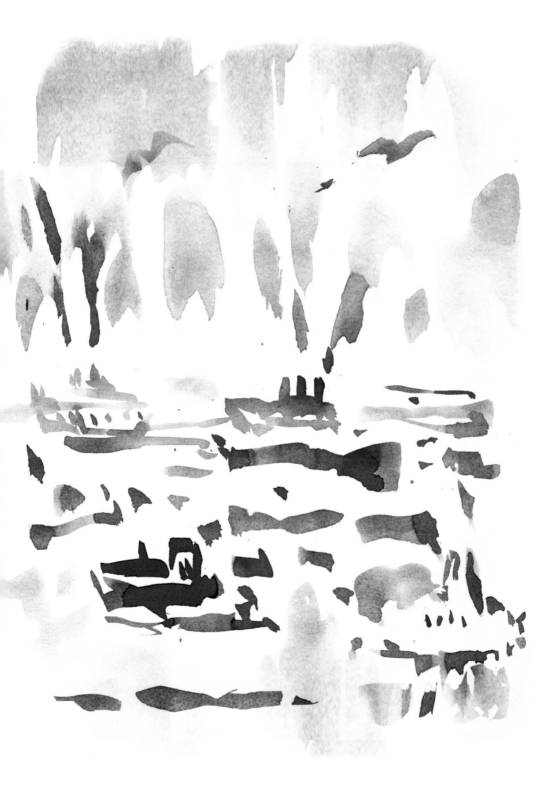

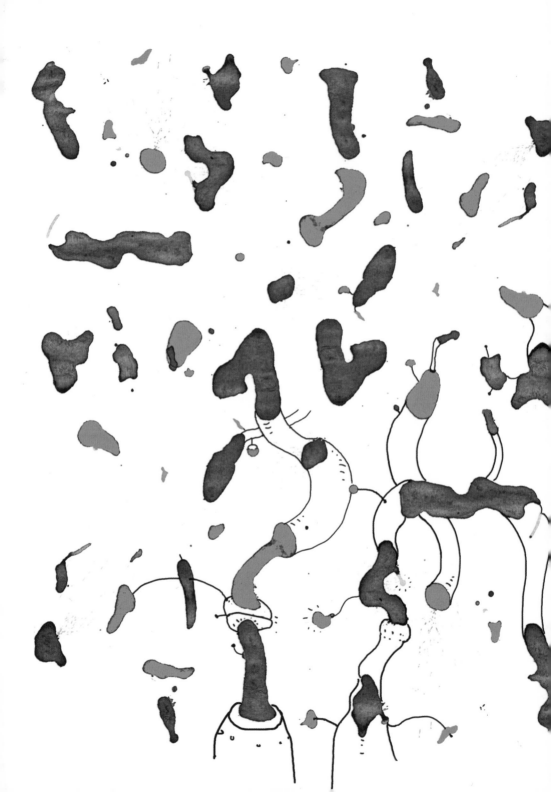

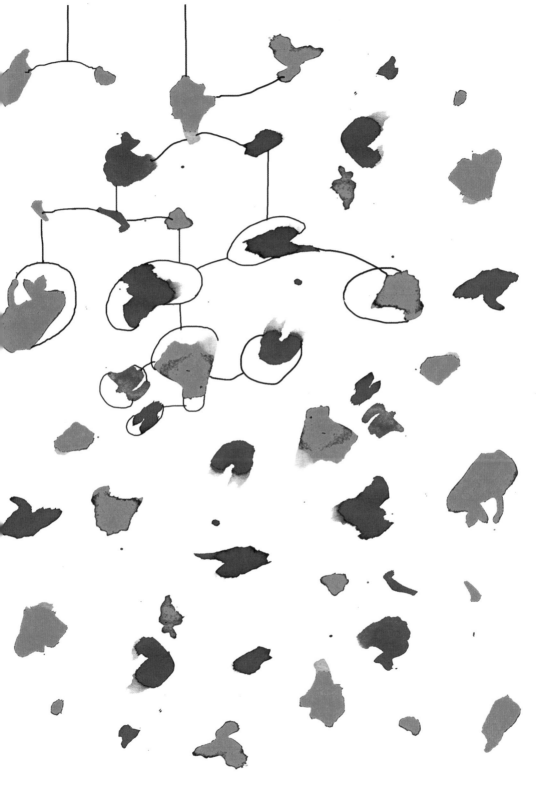

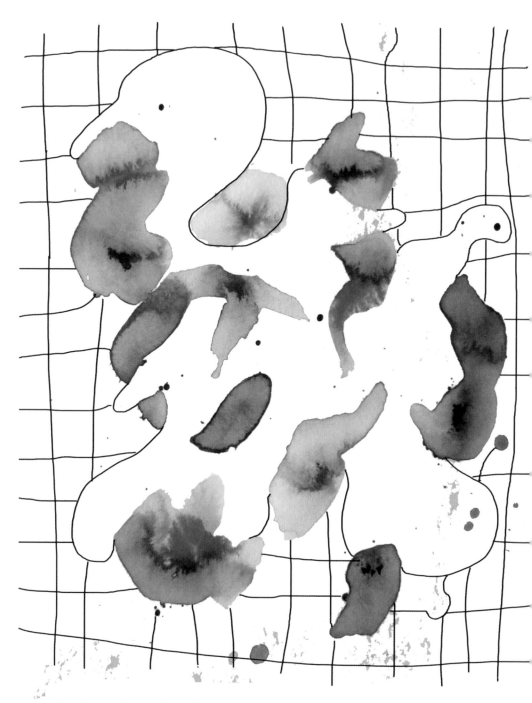

NO IDEA? IT DOESN'T MATTER.

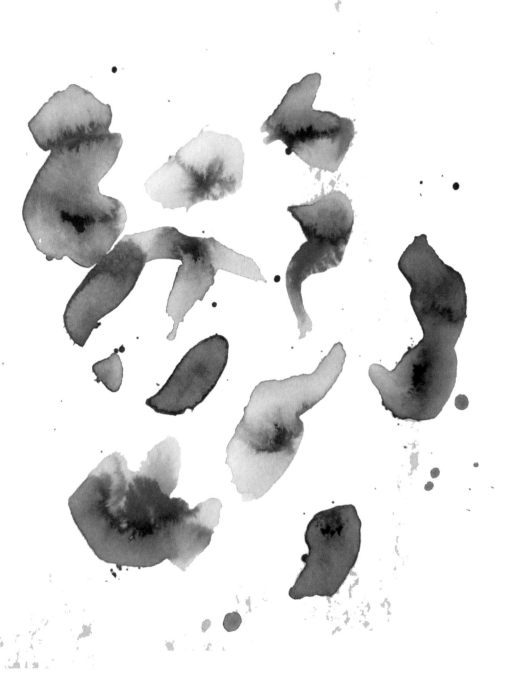

SOMETIMES ABSTRACT STUFF IS BETTER.

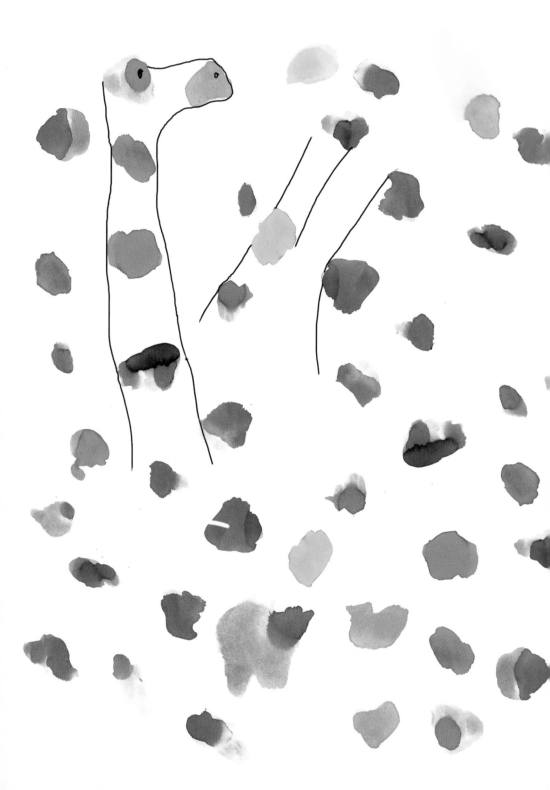

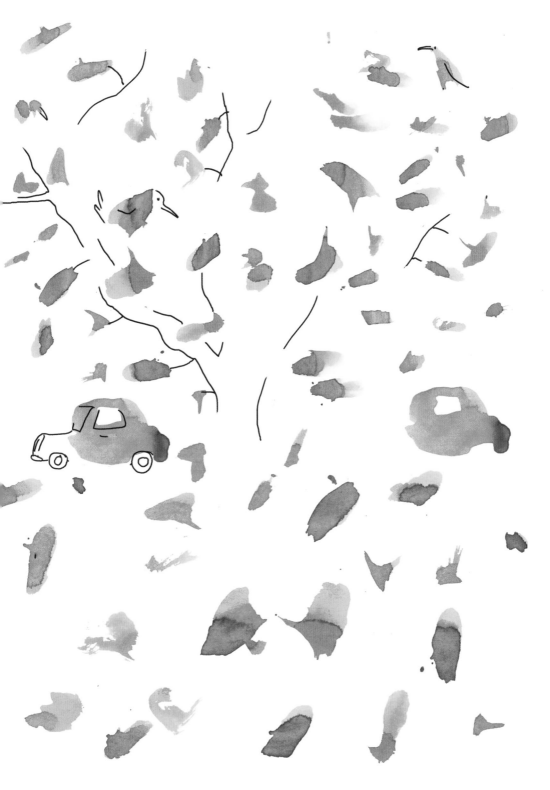

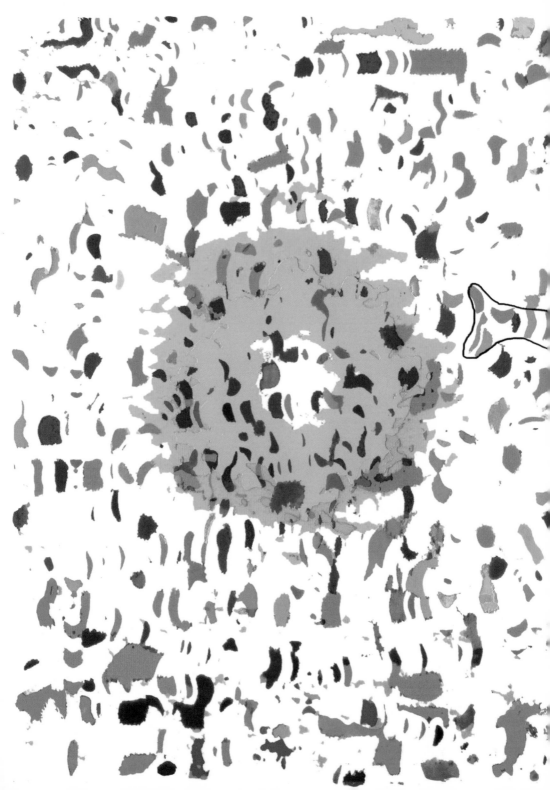

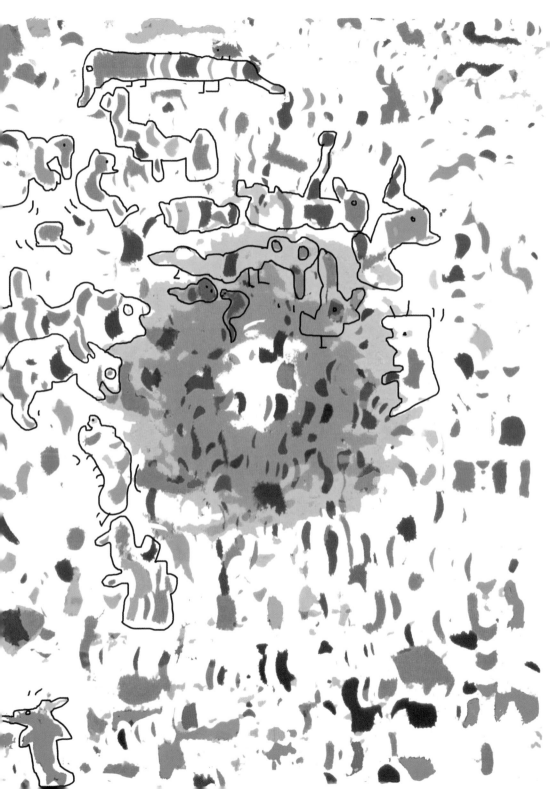

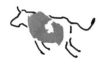

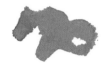

THERE'S NOTHING MORE RELAXING
THAN LYING BACK AND WATCHING
THE COWS FLOAT BY.

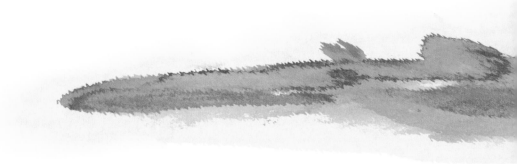

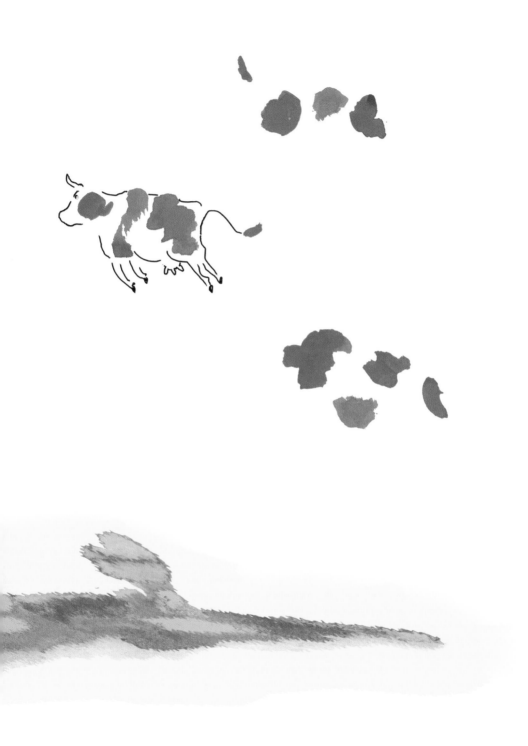

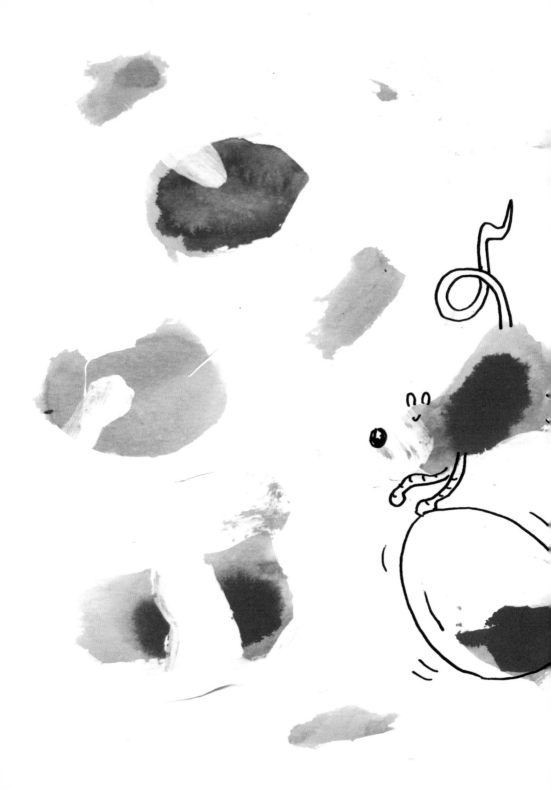

HIRAMEKI

STEP 6

INTERACTIONS

WHAT WOULD ONE BLOT
SAY TO ANOTHER?

A LITTLE CROWD OF PEOPLE, ALL SHAPES AND SIZES
NOT SO LIVELY, BUT FULL OF SURPRISES

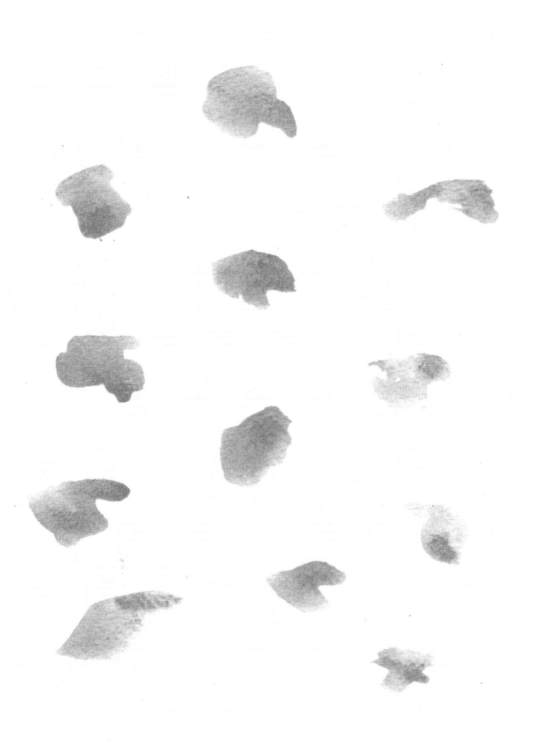

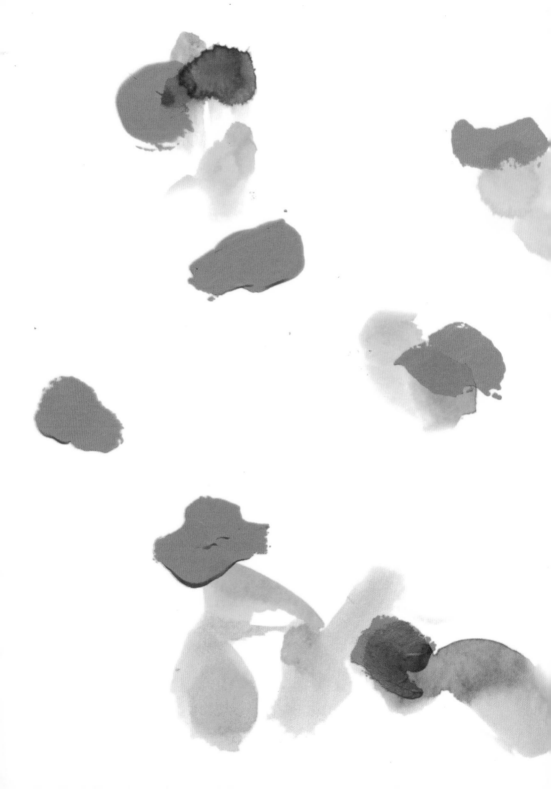

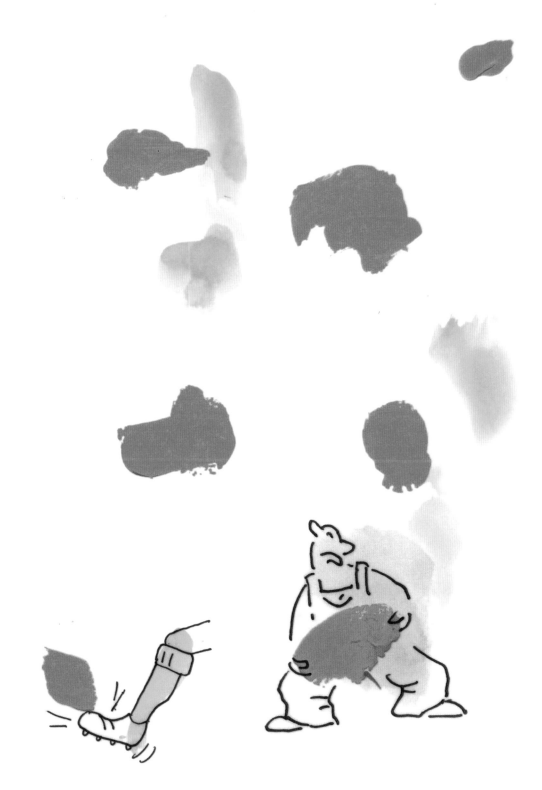

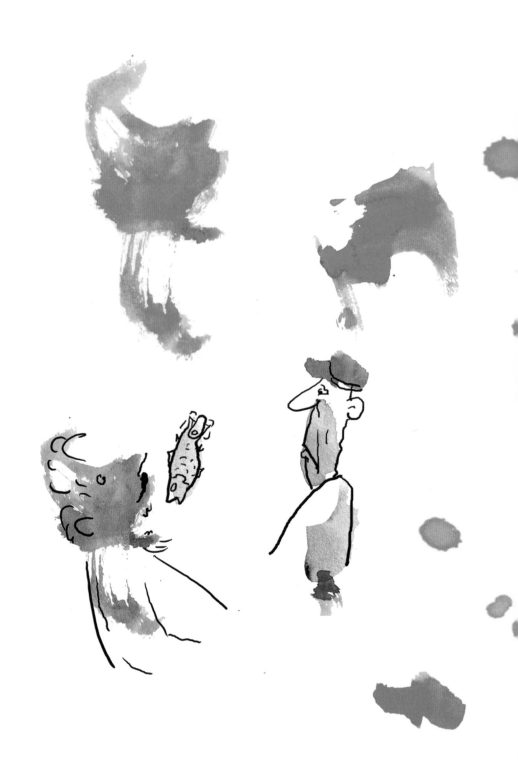

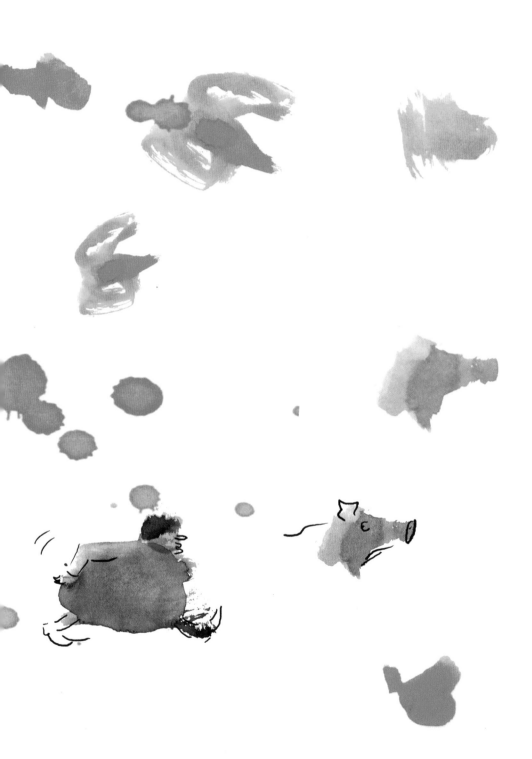

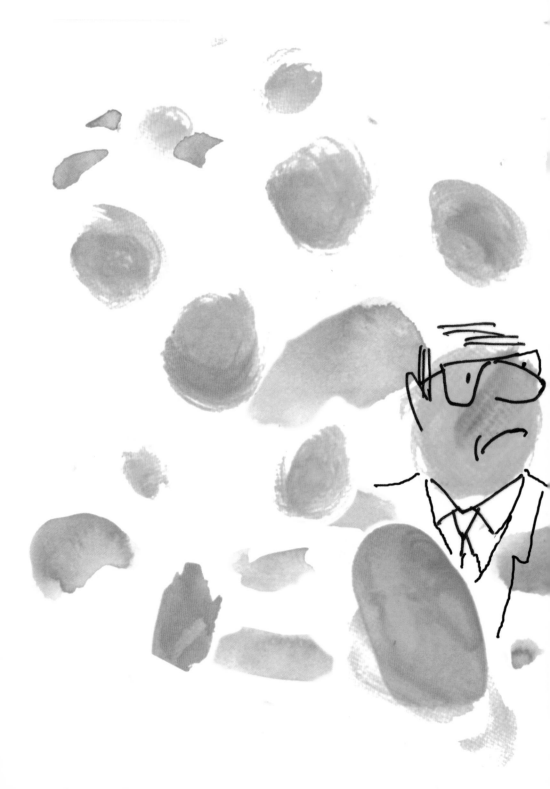

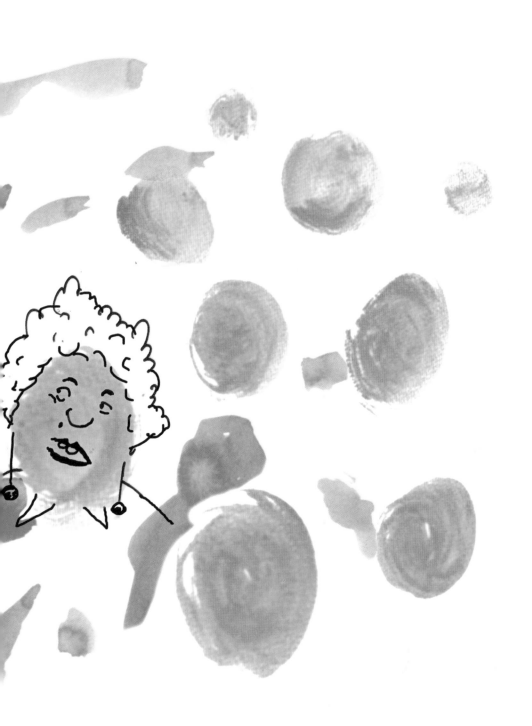

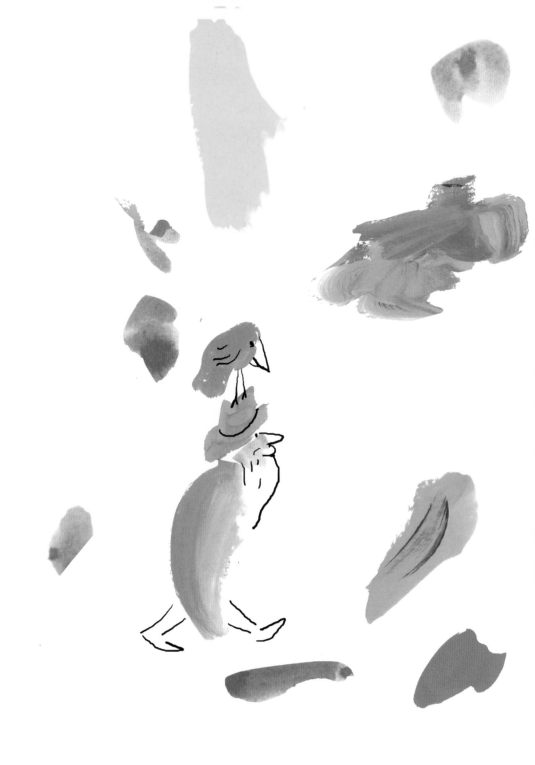

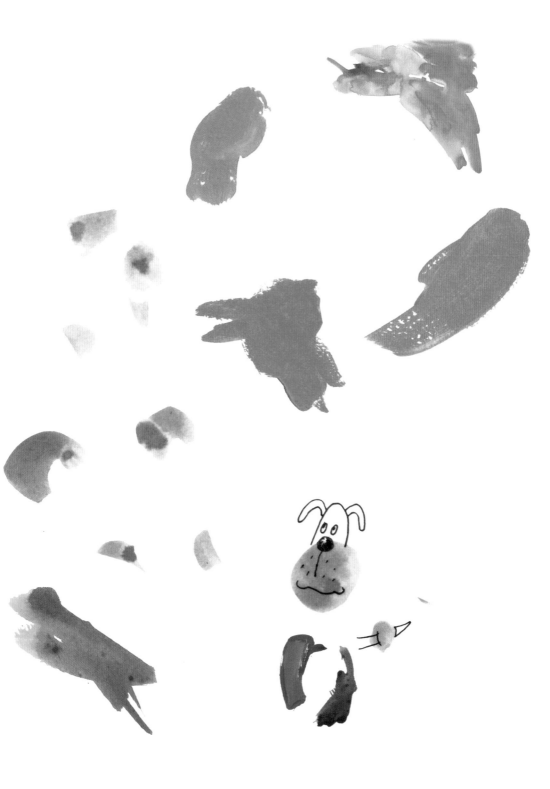

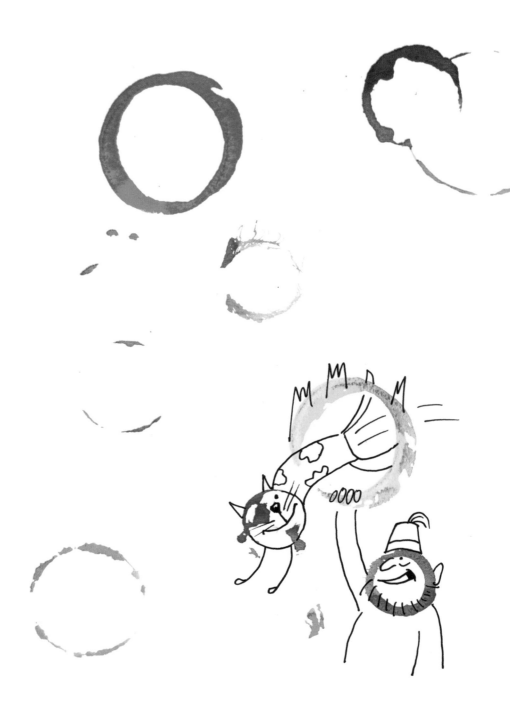

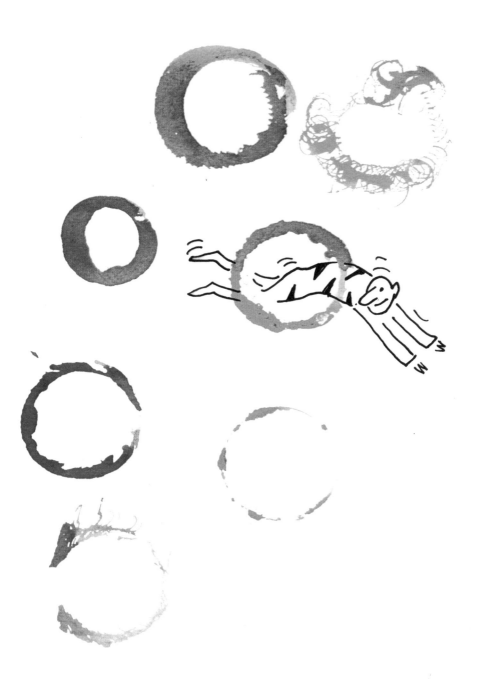

IN SPACE YOU'LL FIND LOTS...

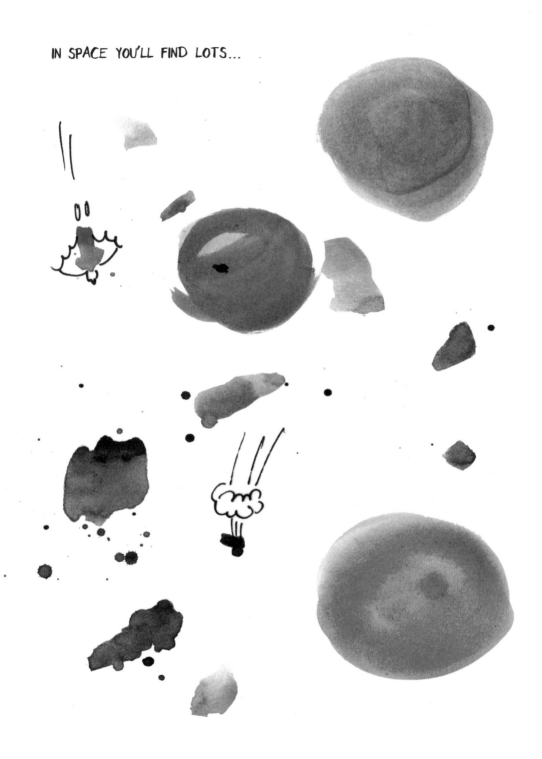

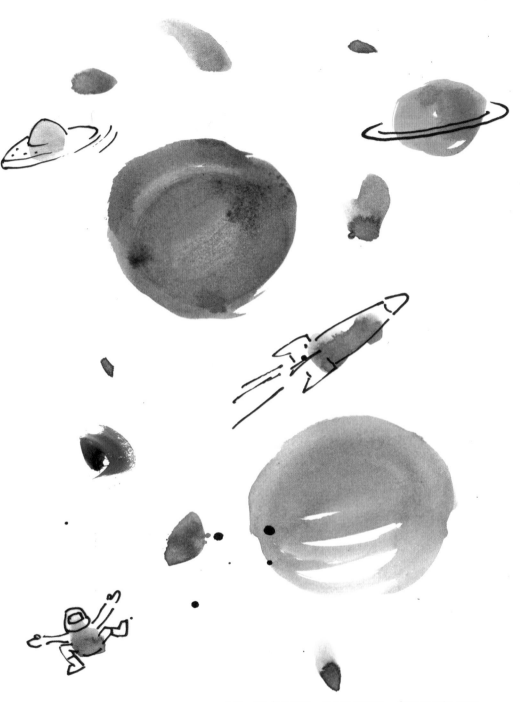

...OF PLANETS, ROCKETS, ASTROBLOTS.

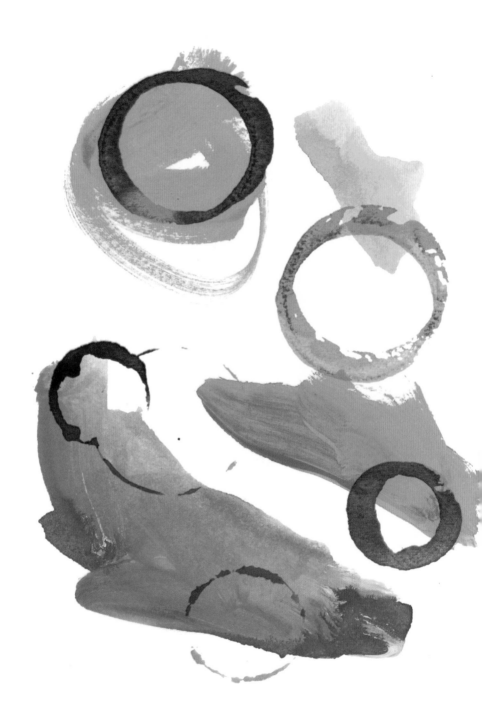

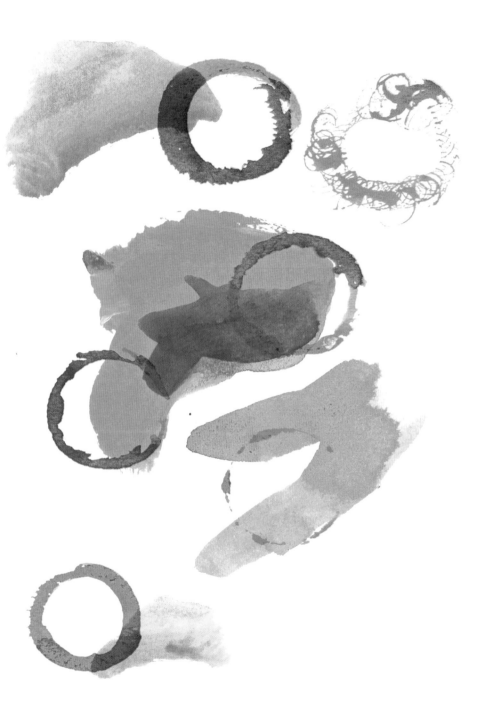

CLOWNS WITH FROWNS...OR WEARING CROWNS

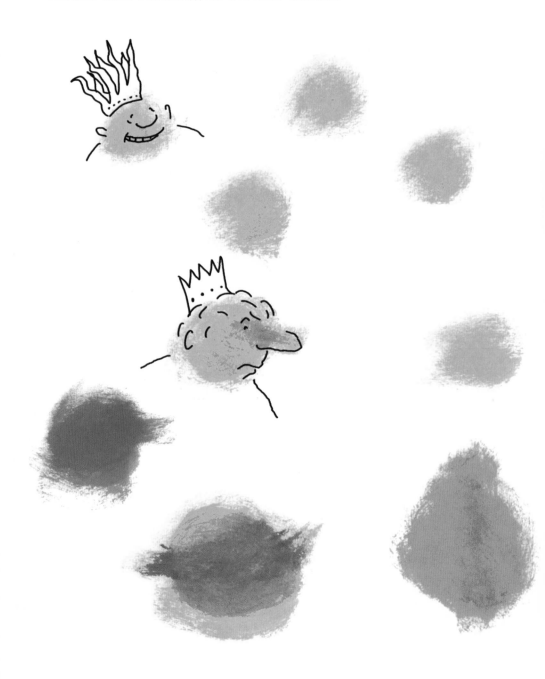

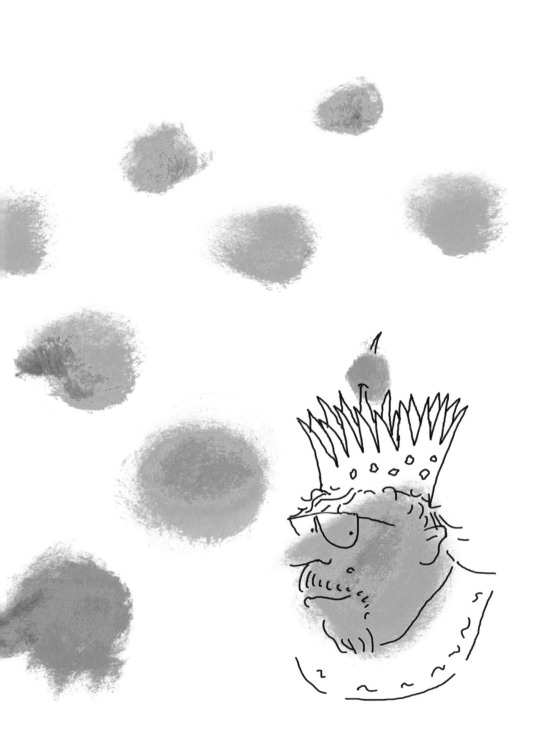

THE PLANETS COME UNDER APE ATTACKS...

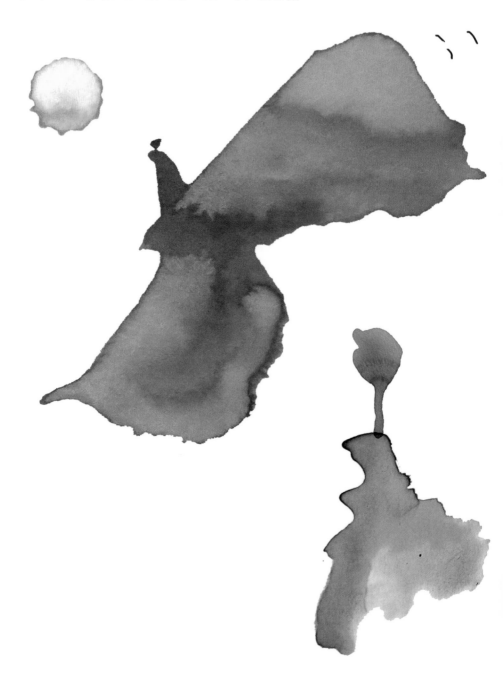

...DRAGONS ARE TURNED INTO TASTY SNACKS.

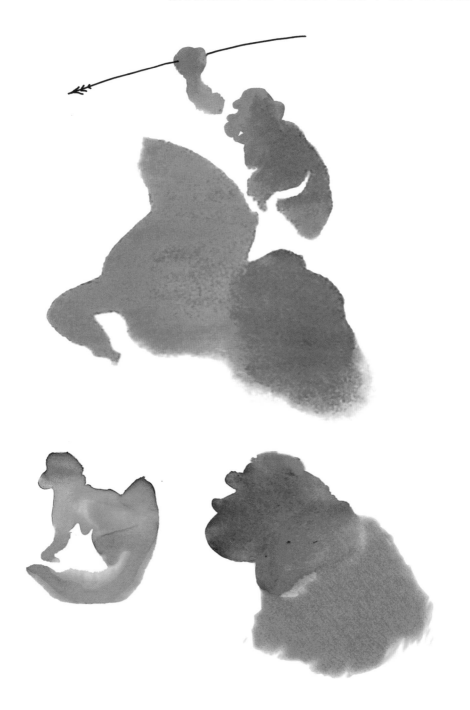

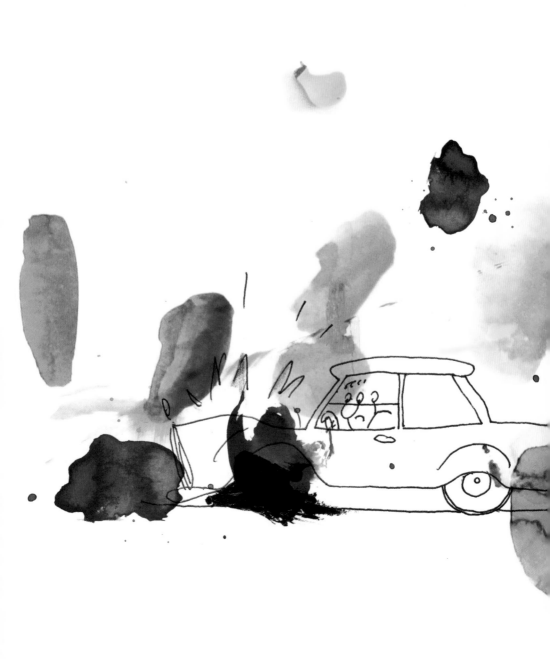

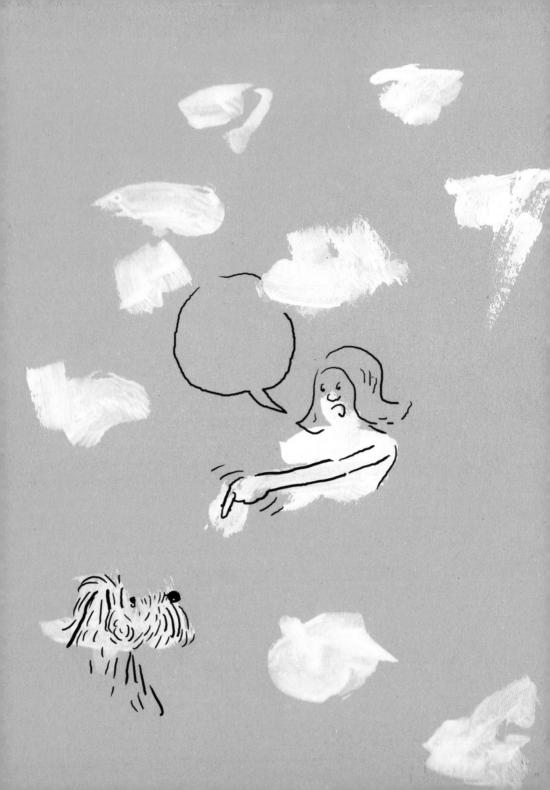

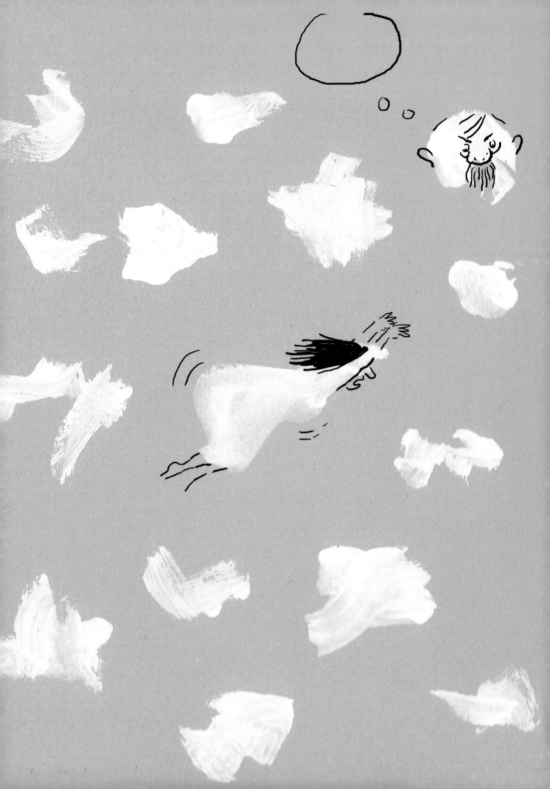

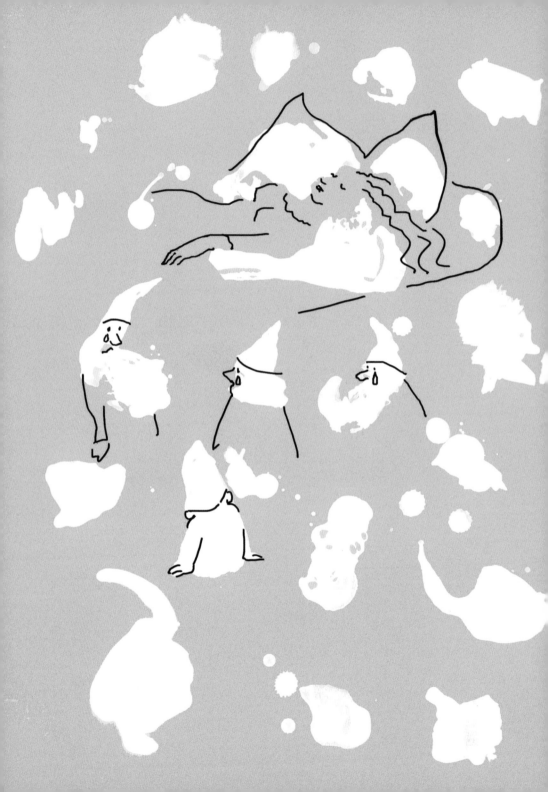

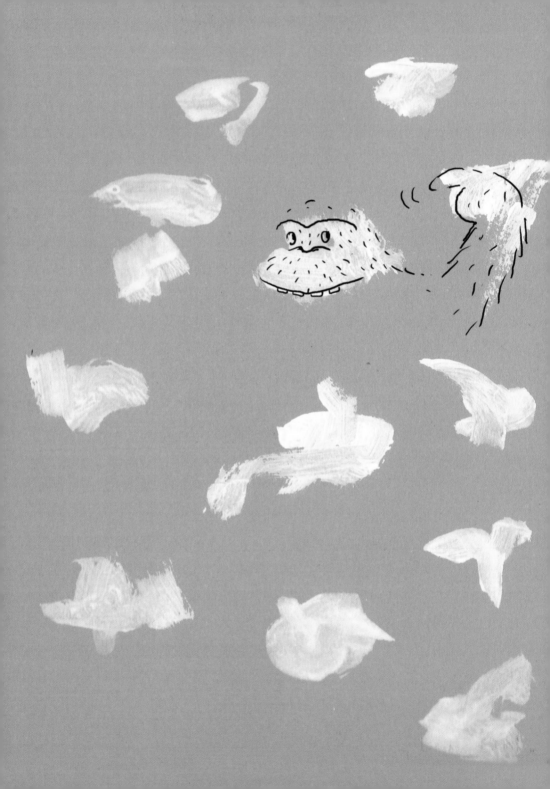

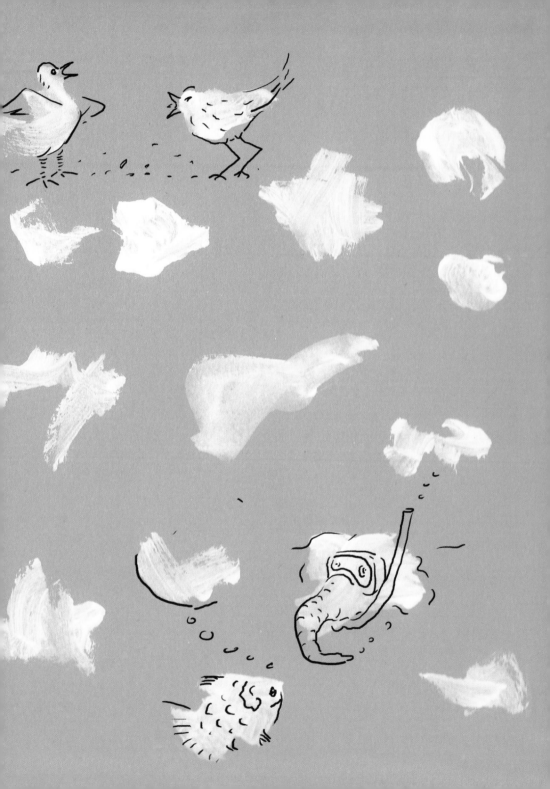

SHOALS OF FISH, COLOURED MARKS...
MURKY SHADOWS COULD BE SHARKS.

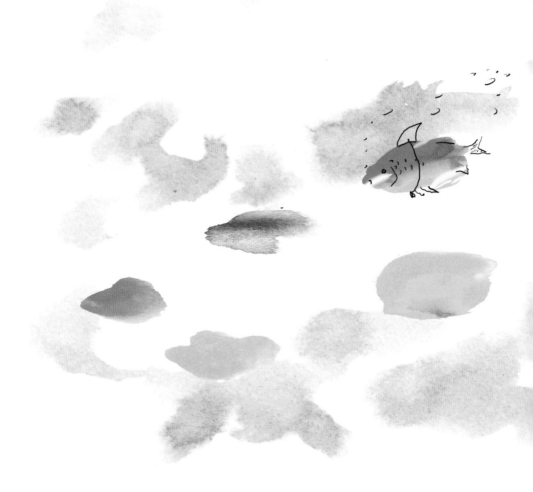

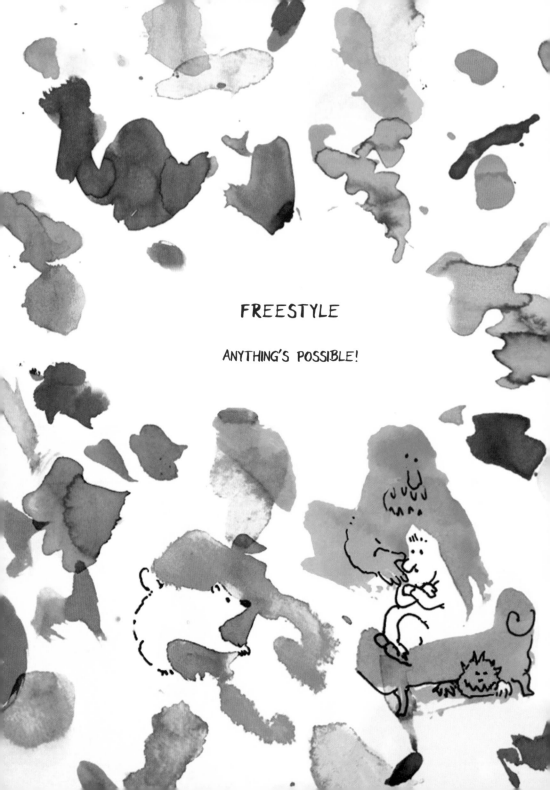

FREESTYLE

ANYTHING'S POSSIBLE!

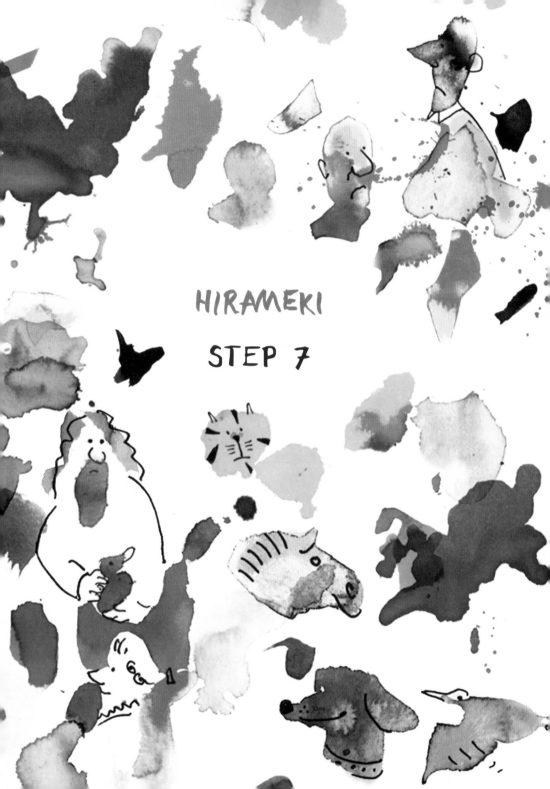

HIRAMEKI

STEP 7

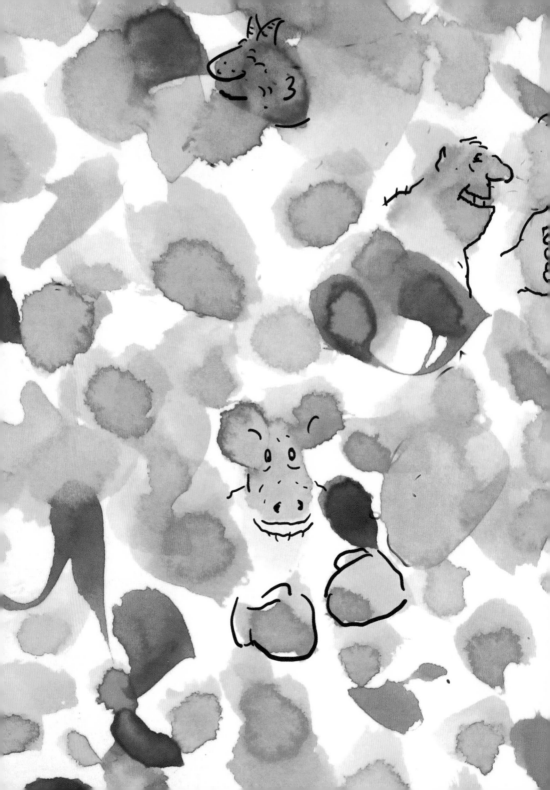

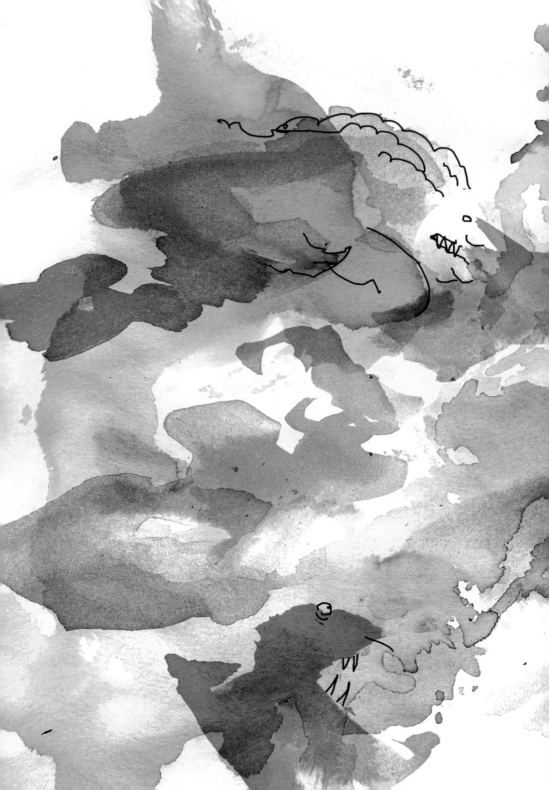

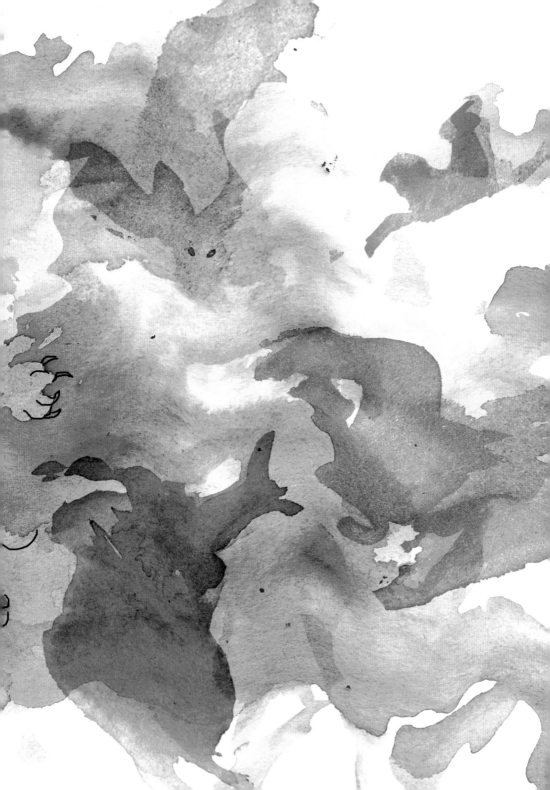

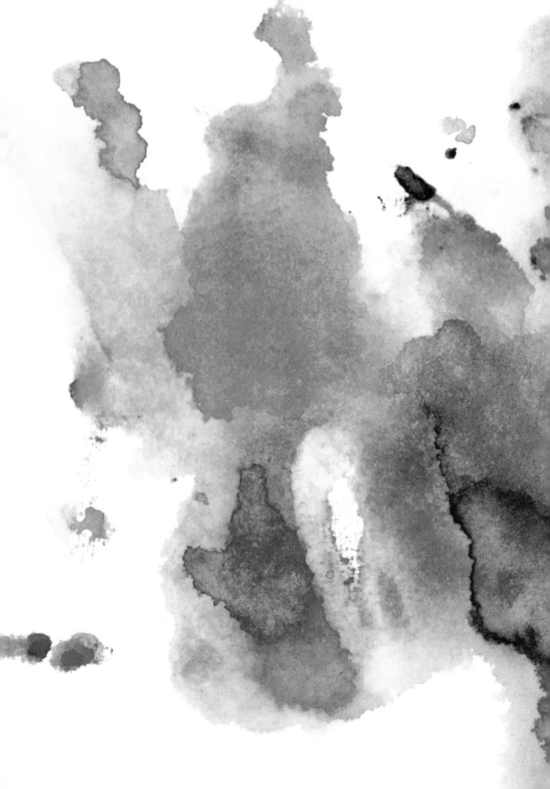

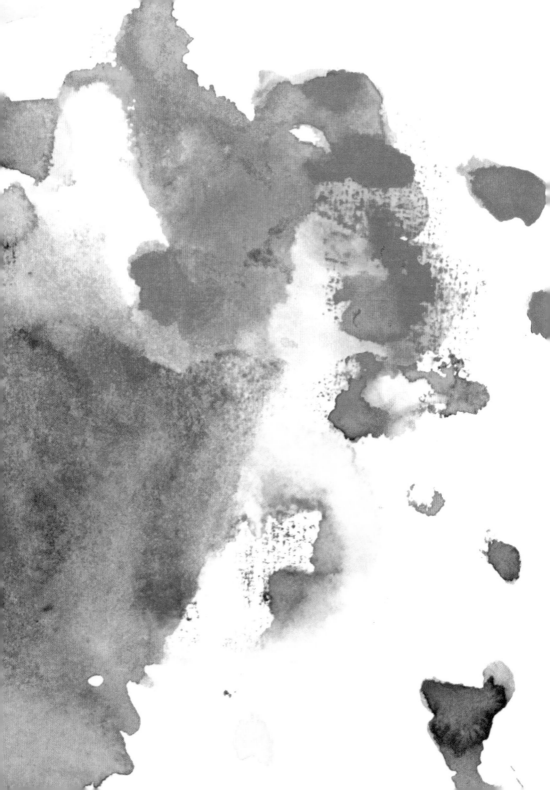

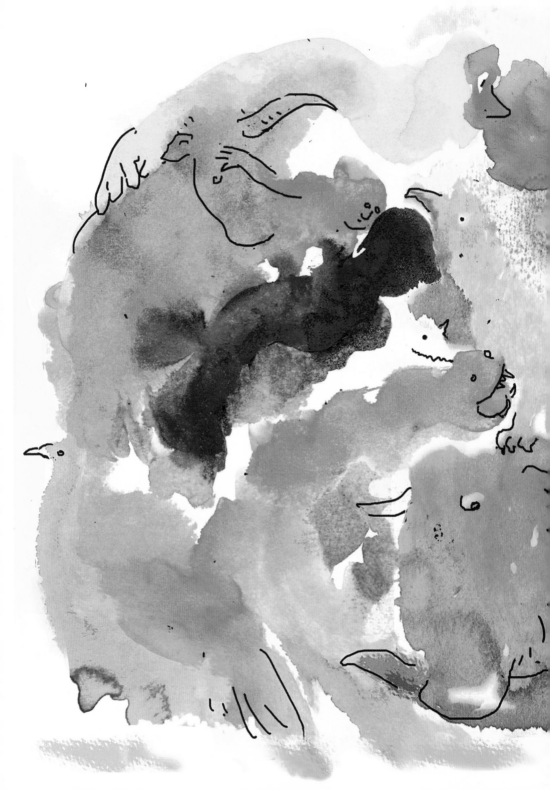

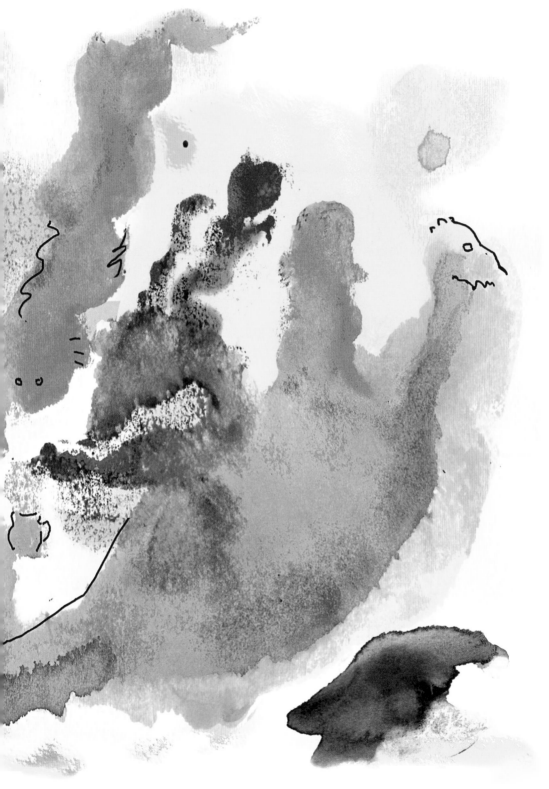

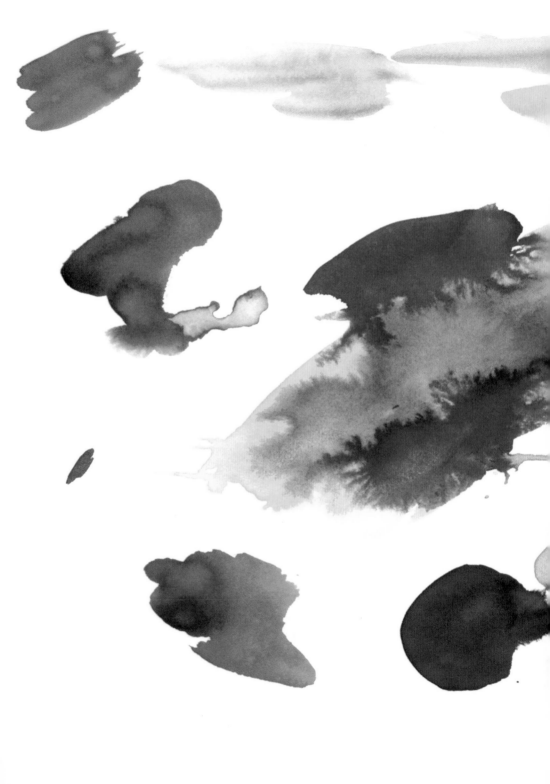

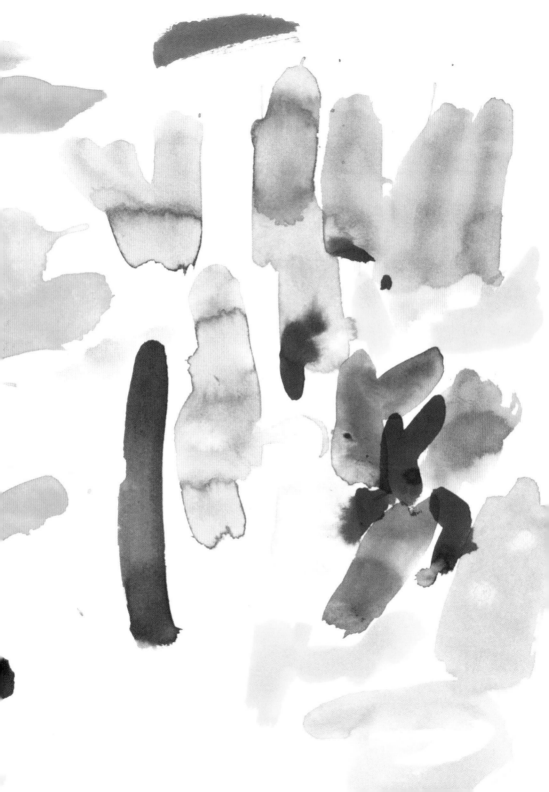

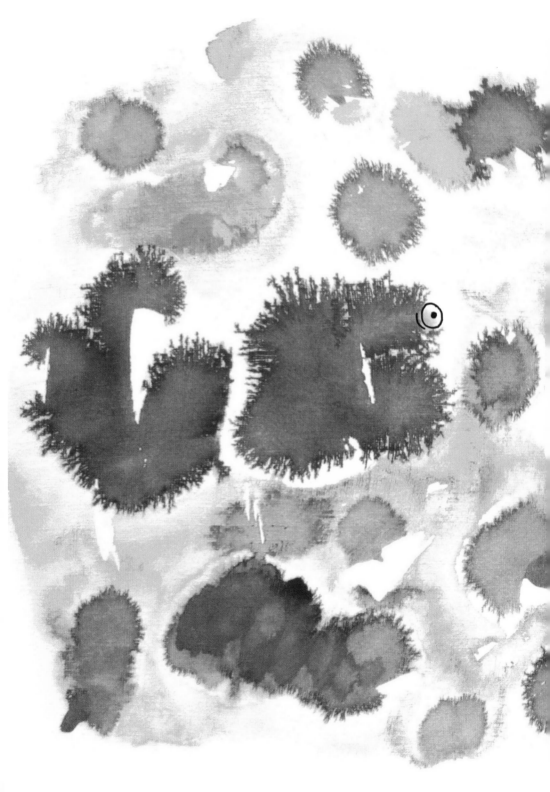

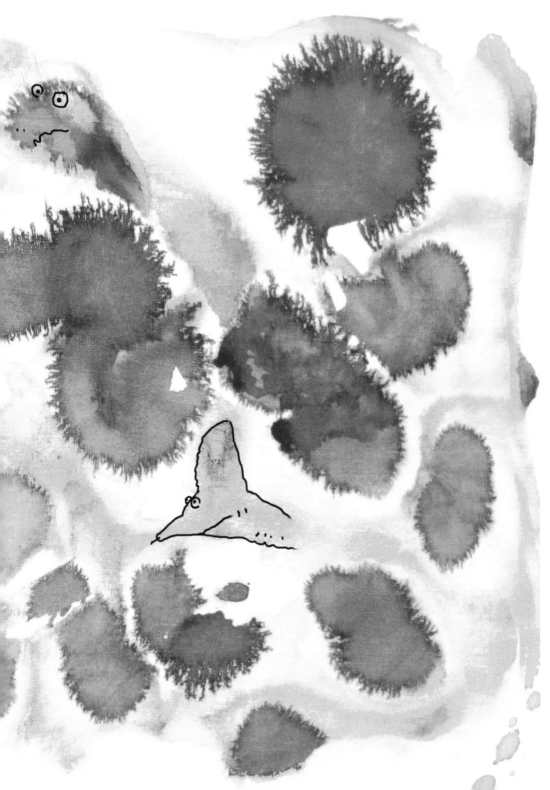

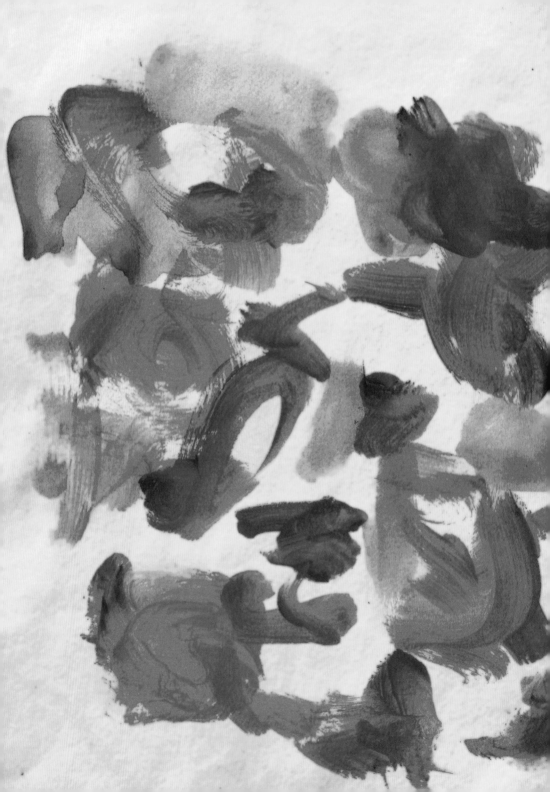

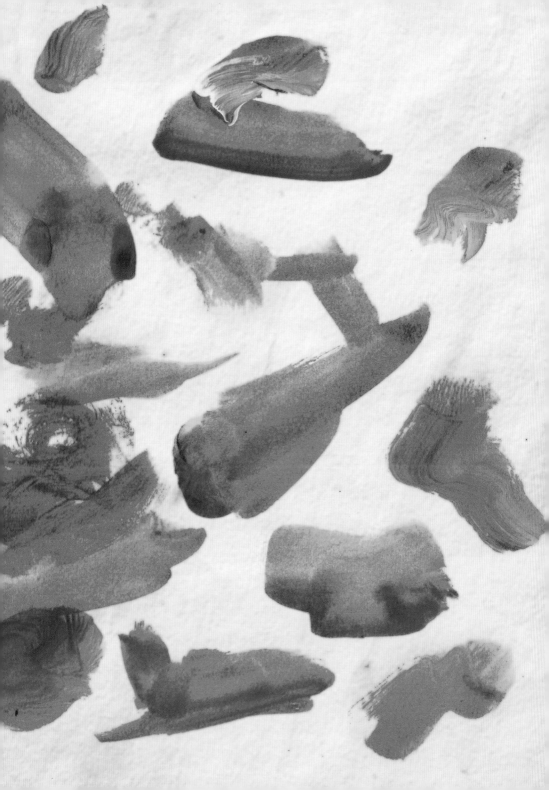

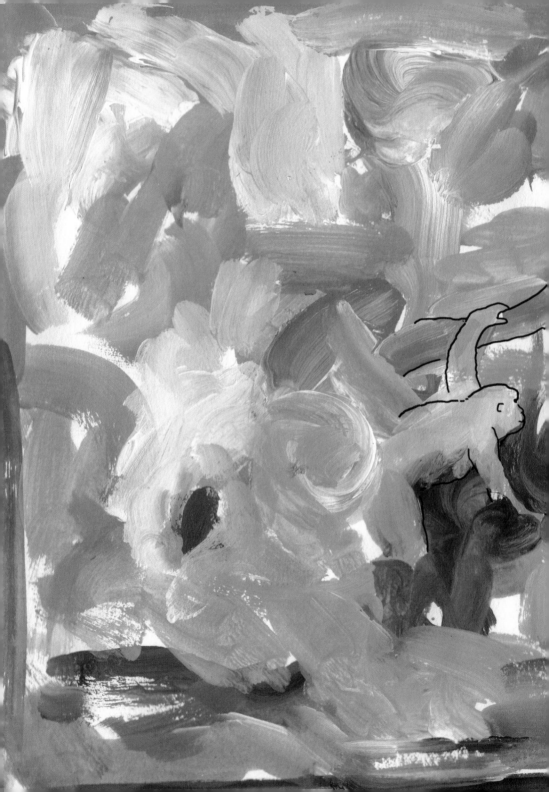

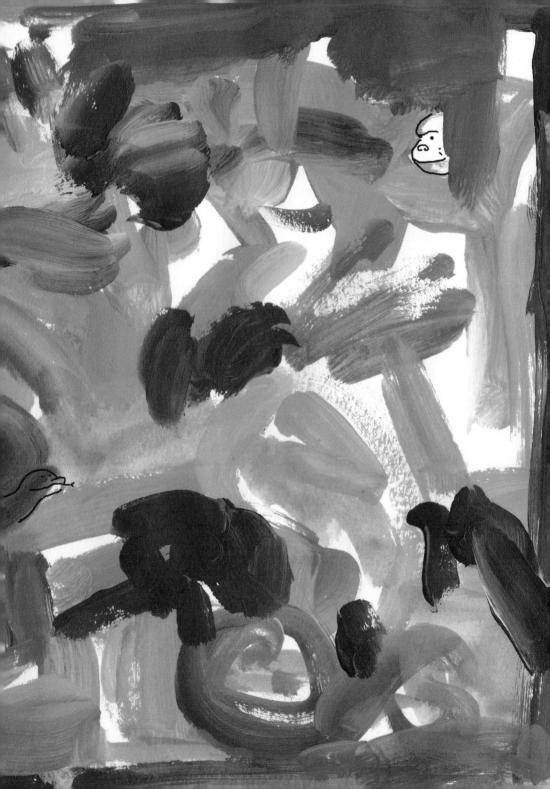

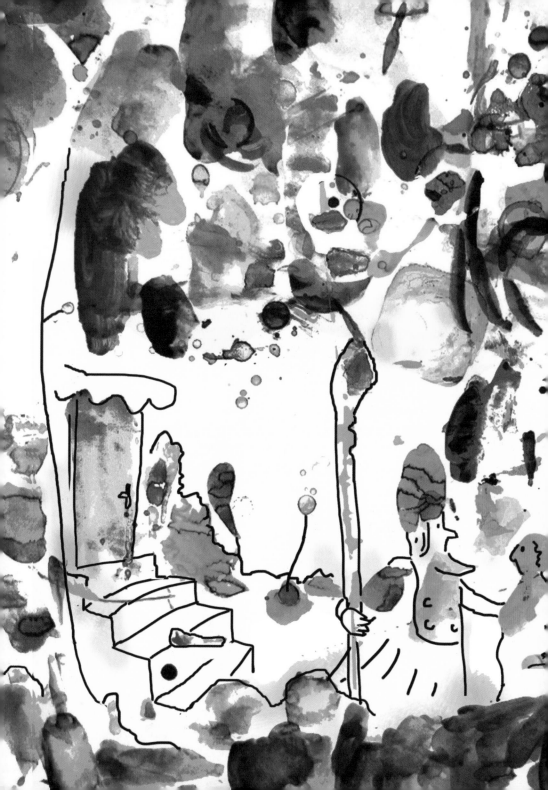

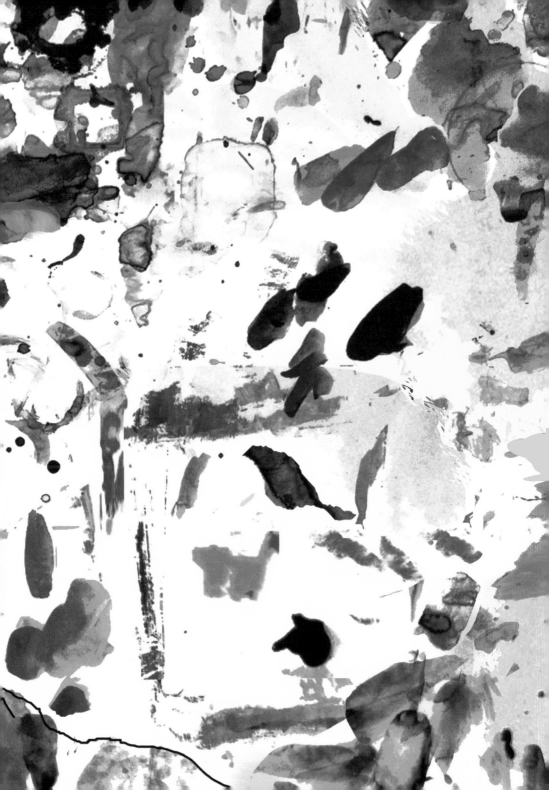

HIRAMEKI INSPIRATION
FROM BLOT TO MASTERPIECE — SENSATION!

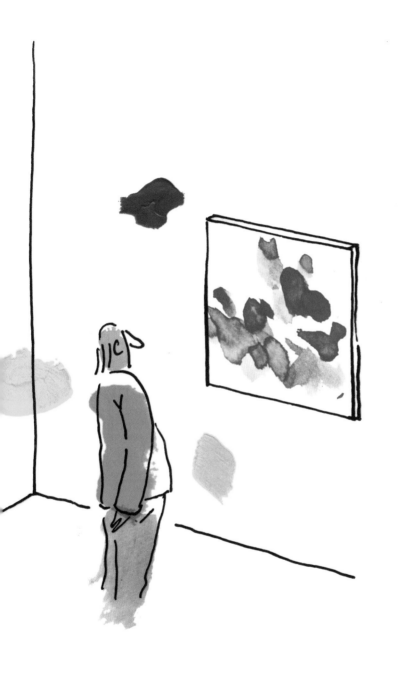

THE ARTISTS PENG AND HU FIRST DISCOVERED THE FANTASTICAL PHENOMENON OF HIRAMEKI
WHEN THEY SAW A COW WITH A SPLOTCH THAT LOOKED JUST LIKE A FAMOUS FILMSTAR.
THEY QUICKLY REALIZED THAT EVEN THE TINIEST BLOT COULD BE EASILY TURNED INTO
SOMETHING AMAZING. HIRAMEKI SOON BECAME A FABULOUS ART FORM FOR EVERYBODY: EVEN
THE MOST INEXPERIENCED DOODLERS CAN PRODUCE HUNDREDS OF SENSATIONAL SCRIBBLES.
PENG AND HU'S PASSION FOR COLLECTING BLOTS AND DOTS OF ALL KINDS HAS TAKEN OVER
THEIR LIVES AND MADE THEM WORLD-FAMOUS.

ALSO AVAILABLE:

ISBN: 978-0-500-29284-6 | £5.95

ISBN: 978-0-500-29352-2 | £5.95

FIRST PUBLISHED IN THE UNITED KINGDOM IN 2016 BY
THAMES & HUDSON LTD, 181A HIGH HOLBORN,
LONDON WC1V 7QX

REPRINTED 2016, 2018, 2020, 2021

ORIGINAL EDITION © 2015 VERLAG ANTJE KUNSTMANN GMBH, MÜNCHEN.
THIS EDITION © 2015 THAMES & HUDSON LTD, LONDON
HIRAMEKI® IS A REGISTERED TRADEMARK OF VERLAG ANTJE KUNSTMANN GMBH.
ALL RIGHTS RESERVED.

BRITISH LIBRARY CATALOGUING-IN-PUBLICATION DATA
A CATALOGUE RECORD FOR THIS BOOK IS AVAILABLE FROM THE BRITISH LIBRARY

ISBN 978-0-500-29248-8

PRINTED AND BOUND IN CHINA

Be the first to know about our new releases,
exclusive content and author events by visiting
thamesandhudson.com
thamesandhudsonusa.com
thamesandhudson.com.au

MIX
Paper from
responsible sources
FSC® C102842